REGINALD MARSH'S
NEW YORK

Cynic's Progress

Years ago Rockwell Kent used to sign his splendid decorative drawings *Hogarth Jr*—this despite the fact that his figures are as unworldly as he knows how to make them, that his dislike of crowds makes him live in remote Ausable Forks, N. Y. and take solitary cruises to Tierra del Fuego and Greenland. A far better right to Hogarth's mantle has Reginald Marsh, who held an exhibition of his latest paintings, water colors and prints at New York's Rehn Galleries last week.

Artist Marsh, 34, has painters for parents and a sculptor for a wife. He was born in Paris where his father, Muralist Fred Dana Marsh, and his mother were studying painting. His wife, Betty Burroughs, recently had a show at the Weyhe Gallery. He was graduated from Yale in 1920, studied at the Art Student's League of New York, later under John Sloan and Kenneth Hayes Miller. His smudgy drawings of U. S. types appear in *The New Yorker*, *The New Masses*.

Reginald Marsh is not a lady's painter. Like Hogarth, he takes crowds for his subject, vulgar, sweating, bestial crowds. He likes to see burlesque shows, dance marathons, bread lines, bathing beaches. He draws them with a line that approaches the British master in brilliance but with a color that is still as crude as his subjects. All his sympathies are reserved for locomotives. Wrote the New York *Evening Post*:

"In 'Locomotives Watering' there are the lyricism and unashamed romantic abandon which this type of subject evokes in this artist; human beings may be vulgar, pretentious, obvious, but a locomotive is always elegant, chic and glamorous."

Artist Marsh has followed the recent revival of interest in mural painting. Paintings shown last week were not on canvas but in tempera on panels coated with gesso. They had an obvious architectural quality. Best were "Swinging Carrousel," a tremendously forceful study of figures whirling on a Coney Island merry-go-round, and "Gaiety Burlesque," an etching of bloated faces leering at a Callipygian beauty on a runway, that was listed in the Institute of Graphic Arts' 50 prints of the year.

FROST & MORRISON

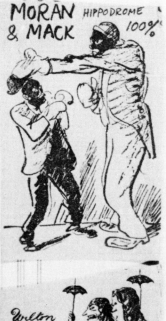

MORAN & MACK HIPPODROME 100%

Walton Sisters 75%

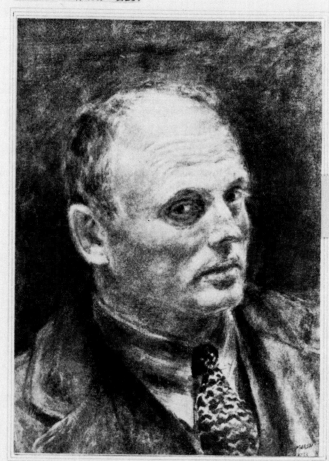

BILL ROBINSON PALACE 75%

magazine of art

SELF-PORTRAIT *1933*

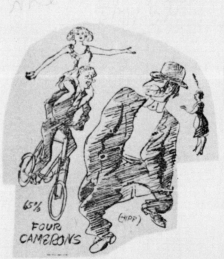

65%

FOUR CAMERONS

(HIPP)

A painter of the city is **Reginald Marsh** who was born 36 years ago to Muralist Fred Dana Marsh in Paris. As a tousle-headed boy (he is now almost bald) he went to Lawrenceville, later to Yale. In spite of his very proper education, Artist Marsh thinks "well bred people are no fun to paint," haunts Manhattan subways, public beaches, waterfronts, burlesque theatres for his subjects. The Metropolitan and Whitney Museums thought enough of his work to purchase examples.

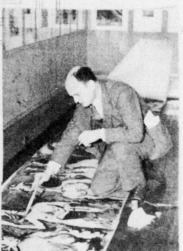

International

REGINALD MARSH
"Well bred people are no fun to paint."

West Branch, Iowa (Engraving

REGINALD MARSH'S NEW YORK

PAINTINGS, DRAWINGS, PRINTS AND PHOTOGRAPHS

154 Illustrations, Including 4 in Full Color

MARILYN COHEN

WHITNEY MUSEUM OF AMERICAN ART
in association with
DOVER PUBLICATIONS, INC.
NEW YORK

Copyright © 1983 by the Whitney Museum of American Art, 945 Madison Avenue, New York, N.Y. 10021 All rights reserved under Pan American and International Copyright Conventions.

Published in Canada by General Publishing Company, Ltd., 30 Lesmill Road, Don Mills, Toronto, Ontario.
Published in the United Kingdom by Constable and Company, Ltd., 10 Orange Street, London WC2H 7EG.

Reginald Marsh's New York is a new work, first published by the Whitney Museum of American Art in association with Dover Publications, Inc., N.Y., in 1983.

The drawings in Figs. 7, 22, 24, 53, 85, and 135 appeared originally in *The New Yorker* and were copyrighted © in the years 1929, 1930, 1931, and 1932 by The New Yorker Magazine, Inc.

Manufactured in the United States of America
Dover Publications, Inc., 180 Varick Street, New York, N.Y. 10014

Library of Congress Cataloging in Publication Data

Cohen, Marilyn, 1949–
 Reginald Marsh's New York.

 Catalogue of an exhibition held at the Whitney Museum of American Art, New York, N.Y., June 29-Aug. 24, 1983, and at other museums.
 Bibliography: p.
 1. Marsh, Reginald, 1898-1954—Exhibitions. 2. New York (N.Y.) in art—Exhibitions. I. Whitney Museum of American Art. II. Title.
N6537.M377A4 1983 760'.092'4 83-6465
ISBN 0-486-24594-2

CONTENTS

Unless otherwise indicated, all works reproduced, including photographs, are by Reginald Marsh.

FOREWORD

The association of Reginald Marsh with the Whitney Museum of American Art goes back to the Whitney Studio Club (a precursor of the Whitney Museum), founded by Gertrude Vanderbilt Whitney in 1918. In 1924 Marsh had his first one-man show of oils and watercolors at the Club. In 1930, the year the Whitney Museum was founded, Mrs. Whitney decided to upgrade her collection, and Juliana Force, first Director of the Museum, purchased *Why Not Use the "L"?* directly from the artist. In 1955, the year after Marsh's death, Lloyd Goodrich, his lifelong friend and then Director of the Museum, arranged a retrospective exhibition at the Whitney Museum. In addition to *Why Not Use the "L"?*, the Permanent Collection by then included *Twenty Cent Movie* and *Human Pool Tables*, all outstanding examples of the artist's work from the 1930s. *Negroes on Rockaway Beach* was subsequently given to the Museum by Mr. and Mrs. Albert Hackett, Mr. Goodrich's sister and brother-in-law, who have also recently promised *Minsky's Chorus* to the Museum in honor of Edith and Lloyd Goodrich.

Reginald Marsh died in 1954 and his wife carefully managed his estate until her death in 1978. It was her intention that his work should be available to as wide a public as possible. Her unusual and generous bequest distributed the estate of her husband to some one hundred museums and collections across the country; certain institutions became centers for concentrated study of the artist and his work. She bequeathed to the Whitney Museum of American Art almost all of Marsh's paintings in her possession executed prior to 1930, as well as hundreds of drawings and sketches. A considerable amount of archival material has subsequently been given by the Museum to the Archives of American Art, where it will be more accessible for study. The Whitney received so much material because it is in New York, the city which Marsh ardently loved and painted for thirty years.

Marilyn Cohen is currently writing her dissertation on Marsh at the Institute of Fine Arts, New York University. When she first began research on the artist, she contacted the Whitney Museum to see the collection, especially the works from the bequest, since they are the roots of Marsh's art of the 1930s. In 1980 she presented a paper at the Whitney Symposium on American Art entitled "Reginald Marsh and the Communications Revolution." She then suggested an exhibition and a book based in part on the ideas of that paper. She believed that Marsh's art, so connected to the thirties, to New York, and to popular culture, would be entertaining and interesting for the general public associated with the Whitney Museum. It is a pleasure to continue her association with the Museum through this project so closely identified with our history.

It is particularly appropriate that the work of an artist who recorded the life of the people of New York City is being presented at our new branch museum, located in the headquarters building of Philip Morris Incorporated at Park Avenue and Forty-second Street, one of the busiest intersections in the world. Philip Morris generously supports the branch museum and has provided funding to enable the exhibition to travel to other museums.

TOM ARMSTRONG
Director
Whitney Museum of American Art

This book was published on the occasion of the exhibition "Reginald Marsh's New York" at the Whitney Museum of American Art at Philip Morris, June 29–August 24, 1983, organized by Marilyn Cohen, Guest Curator. After its presentation in New York, the exhibition will travel to the Terra Museum of American Art, Evanston, Illinois; the San Jose Museum of Art, California; and the Georgia Museum of Art, University of Georgia, Athens. The publication was organized at the Whitney Museum of American Art, New York, by Doris Palca, Head, Publications and Sales; Sheila Schwartz, Editor; James Leggio, Associate Editor; and Amy Curtis, Secretary.

Designer: Carol Belanger Grafton
Typesetter: Trufont Typographers, Inc.
Printer: The Murray Printing Company

ACKNOWLEDGMENTS

Since Felicia Meyer Marsh's bequest widely distributed the estate of her husband, Reginald Marsh, a Marsh exhibition now more than ever depends on the generosity of lenders. I am indebted to each of the individuals and institutions that have made loans to this exhibition.

I would also like to thank those people who have gone out of their way to facilitate this project: Carolyn Klein, the curator for the collection of Marjorie and Charles Benton; Thomas P. Bruhn of the William Benton Museum of Art; Steven Miller, Nancy Kessler-Post, and Jennifer Bright of the Museum of the City of New York; the staff of the Archives of American Art in Washington, D.C., including Garnett McCoy, Judy Throm, Colleen Hennessey, and Sheila Hoban; the staff of the Archives of American Art in New York, including William McNaught, Jemison Hammond, and Arleen Pancza; Thomas Styron and Thomas Sokolowski of the Chrysler Museum; Linda Steigleder of the Georgia Museum of Art; and Ronald McKnight Melvin of the Terra Museum of American Art. Ida Balboul of the Metropolitan Museum of Art deserves special mention for arranging the research and photography of Marsh's sketchbooks, as does David L. Weinberg for contributing precious hours toward shaping and clarifying the ideas of both the manuscript and exhibition.

I am grateful to Tom Armstrong, Director of the Whitney Museum of American Art, for his support. I enjoyed the interest and advice of Patterson Sims, Associate Curator, Permanent Collection, of the Whitney Museum. I would especially like to thank Lisa Phillips, Associate Curator, Branch Museums, of the Whitney Museum for the opportunity to organize this exhibition. She guided the project enthusiastically from beginning to end.

As a guest curator I depended a great deal on the staff of the Whitney Museum of American Art: Elizabeth Carpenter, Anita Duquette, Valerie Leeds, Barbi Schecter Spieler, and Sarah Warren. I am especially grateful to Sheila Schwartz and James Leggio for their editorial expertise and to Susan Lubowsky for her help with the installation of the exhibition.

I am indebted to Lloyd Goodrich, Edward Laning, and Norman Sasowsky, whose research and ideas are the backbone of Marsh scholarship. Only after extensive research on Marsh can one fully appreciate the skillful organization and clarity of Mr. Goodrich's book on the artist. Edward Laning, who died in 1981, wrote perceptively and originally on Marsh beginning in the 1940s. Norman Sasowsky catalogued the artist's estate and, with his wife, Mary, oversaw its distribution. He also compiled the catalogue raisonné of Marsh's prints and wrote a provocative essay to go with it. All of these people have done a great deal to record the life and career of Reginald Marsh. I hope this publication will add something to that record, and I would like to thank Hayward Cirker of Dover Publications for making the book possible.

M.C.

REGINALD MARSH'S NEW YORK

INTRODUCTION

Reginald Marsh (1898–1954) painted New York City during the 1930s. He painted the Bowery, Fourteenth Street, Coney Island, and the subway. He painted dance marathons and taxi-dance halls, burlesque queens and Bowery bums. His paintings were immediately popular because they were familiar. They included all the debris of the city—its helter-skelter signs, litter of newspapers and magazines, riot of costume. He captured the aura and pace of the city: the crowds at the beach, at the movies, and on the streets—shopping, stopping, milling—great hives of people caught up in a period of national economic disaster, yet still pursuing their leisure or, like the Bowery bums, passing the time, endlessly waiting.

The details in Marsh's paintings reflect the documentary style which characterized so much of thirties expression.[1] In photography it was the style of Walker Evans and Dorothea Lange. It was a style that concentrated on the common man and which used details, like the objects atop a dresser in a migrant worker's shack, to make the experience of that room "real." In a period of great self-consciousness, the documentary approach was a way for the nation to share the experience of economic calamity. It was as if the times demanded a realistic confrontation with events.[2]

Many American painters, too, turned to the social landscape for their subject matter. Some, like Ben Shahn and Jack Levine, were critical of what they found. The Regionalist painters—Thomas Hart Benton, John Steuart Curry, and Grant Wood—treated the American scene affirmatively, finding in American history and social life the stuff that spirited murals could be made of. Marsh was often viewed as an urban Regionalist. Where Benton and Curry found baptisms and barn dances in the Midwest, Marsh found breadlines and taxi-dance halls in the city. More interested in the contemporary scene, Marsh had a less historical orientation than either Curry or Benton, but in the paintings of all three the figure scale is large, the movements energetic, and there is a concentration on communal events that calls attention to the "big picture" of American life.

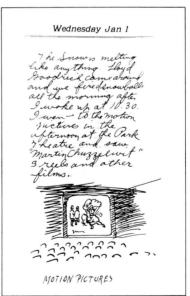

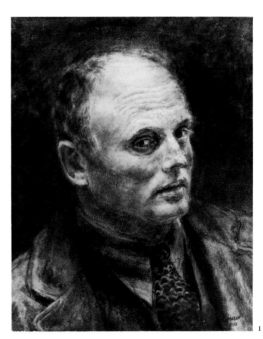

Fig. 1. *Self-Portrait*, 1933. Tempera on panel, 16 × 12 inches. Addison Gallery of American Art, Phillips Academy, Andover, Massachusetts.
Fig. 2. Diary, 1913. Reginald Marsh Papers, Archives of American Art, Smithsonian Institution, Washington, D.C.

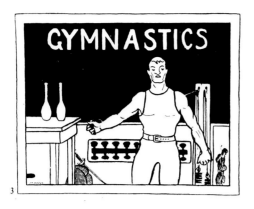

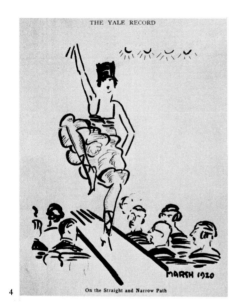

On the Straight and Narrow Path

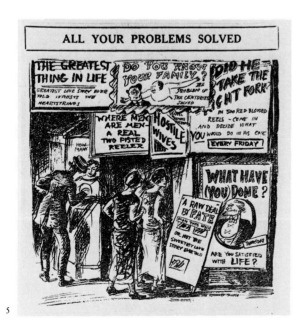

This big urban picture was one being transformed by the communications industries—by movies, radio, and advertising. The spectacles, entertainments, and street life Marsh saw were new. The people of the 1930s, says the cultural historian Warren Susman, were people of "sight and sound."[3] Besieged and assaulted by movies

and radio, they may have been the first to participate in a truly popular culture, because movies and radio—through sight and sound—reached more people. Cultural symbols were more accessible than ever before. Perhaps the best symbol for the new era was Radio City Music Hall (which opened in 1932), suggesting a metropolis built on sound. The first "talkie," *The Jazz Singer*, came out in 1927 and by 1933 Franklin Delano Roosevelt was making sophisticated use of radio in his fireside chats. The fast banter so much a part of newsroom movies of the time, climaxing in 1940 with *His Girl Friday*, parodied the new pace of life. How many movies in the 1930s showed the passage of time by dropping a bundle of newspapers on the ground with headlines and dates being ripped away? Marsh's paintings include the same details of headlines, dates, and signs, the barrage of "sight and sound" that bombarded this first media generation.[4]

Yet for all the contemporary detail, there is something about Reginald Marsh's New York that is not quite real. While headlines and street signs say this is New York, his characters seem lost in a dreamworld. Recognizing this, Thomas Garver called it "the city that never was."[5] "A tragic mood and a quality of fantasy underlie much of his work," wrote Norman Sasowsky.[6] The personal and fantastic character of Marsh's art was present simply in the selectivity of his approach to the city. As Edward Laning noted years ago, Marsh constantly returned to the same places and painted the same things.[7] His art is restricted to people on display, whether inside or outside. His enormous oeuvre ultimately can be reduced to a few themes.

Behind its public face, Reginald Marsh's art is determined by a singular and personal vision—a vision that took him to the past and to the present. Indeed, while at first glance his paintings and prints evoke New York in the thirties, with its tawdry amusement parks and brazen floozies, at another glance they evoke scenes from the art-historical past, Last Judgments and Rapes of the Sabine Women. At some point the Bowery, burlesque, and beach ceased to be real places for Marsh. Within the crowds lurked a limited set of characters that endlessly played out his more private themes: men and women, spectator and performer, seeing and not seeing. These themes, which fully emerged in the thirties, occupied him for the rest of his life, and kept him sketching, photographing, printmaking, and painting incessantly. Only by exploring both the social and personal levels of his art can we finally see Reginald Marsh's New York.

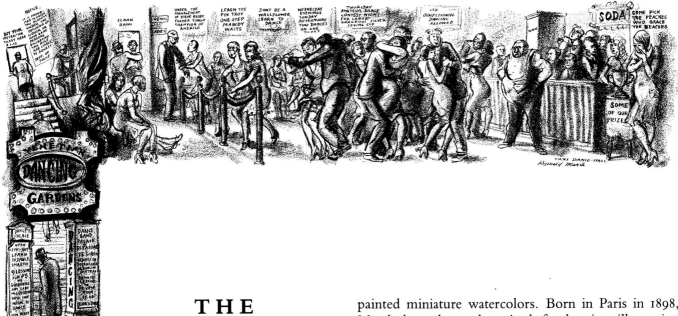

THE
ARTIST
AS
CHRONICLER

Reginald Marsh was a short, shy man with a reddish complexion. He talked little and was given to delivering one-liners "out of the side of his mouth."[8] He affected a kind of dead-end-kid attitude that made Edward Laning, when he first met Marsh, think of him as a young gangster. Jimmy Cagney would have probably gotten the lead had there been a movie called "The Reginald Marsh Story." This self-generated image obscures Marsh's background almost as much as does the subject matter he chose to paint.

Marsh was in fact a well-educated man, born into a financially comfortable family. His paternal grandfather had made a great deal of money in the meat-packing industry in Chicago and Marsh's father, Fred Dana Marsh, a well-known muralist, did not really have to work for a living. Marsh's mother was also an artist, who

Fig. 3. *Gymnastics*, from the Lawrenceville School yearbook, class of 1915. Reginald Marsh Papers, Archives of American Art, Smithsonian Institution, Washington, D.C.
Fig. 4. "On the Straight and Narrow Path," from *The Yale Record*, October 26, 1916. Reginald Marsh Papers, Archives of American Art, Smithsonian Institution, Washington, D.C.
Fig. 5. "All Your Problems Solved," c. 1922–25 (probably from the *New York Daily News*). Clipping in scrapbook no. 3. Reginald Marsh Papers, Archives of American Art, Smithsonian Institution, Washington, D.C.
Fig. 6. Business card, c. 1922–25. Reginald Marsh Papers, Archives of American Art, Smithsonian Institution, Washington, D.C.
Fig. 7. "Venetian Gardens," from *The New Yorker*, February 13, 1932. Clipping in scrapbook no. 5. Reginald Marsh Papers, Archives of American Art, Smithsonian Institution, Washington, D.C.

painted miniature watercolors. Born in Paris in 1898, Marsh showed an early aptitude for drawing, illustrating his diaries (Fig. 2), school yearbooks (Fig. 3), and so on. At Yale (class of 1920) he continued to illustrate, for his college magazine (Fig. 4). His classmates included William Benton, the future senator from Connecticut, and Henry Luce, the founder of *Life* magazine.[9] After graduation, Marsh moved to New York, planning to work as an illustrator. He had no intention of becoming a painter; many of his idols in this period were political cartoonists. In New York in the early twenties he prowled the streets with sketchbook in hand, and sold the drawings to politically diverse magazines and newspapers. "Subway Sunbeams" (Fig. 54), "Bunk," "People We'd Like to Kill but Don't"—these cartoons showed the common foibles and concerns of New Yorkers. In 1922 he got a job at the *New York Daily News* doing a cartoon review of vaudeville and burlesque. He would attend the shows and sketch the acts; the drawings would appear in the paper in a vertical format, accompanied by ratings of the acts (see frontispiece). Later, in 1925, when *The New Yorker* was founded, Marsh became one of its original cartoonists.

These early jobs provided Marsh with a good amount of income and a great deal of free time. He decided to study painting.[10] His marriage to Betty Burroughs, the daughter of the curator of painting at the Metropolitan Museum of Art, and a trip to Paris in 1925 fueled an awakening interest in Old Master painting, an interest encouraged by Kenneth Hayes Miller, who was his teacher at the Art Students League of New York. But Marsh never stopped roaming the streets with his sketchbook, and the same sketches he worked up for his cartoons and illustrations also found their way into his paintings.

Marsh's subjects—taxi-dance halls, burlesque, Coney Island, the Bowery—certainly record the physical and social life of a newly commercialized city. There was a new urban proletariat developing in the twenties and thirties, a population including more working women

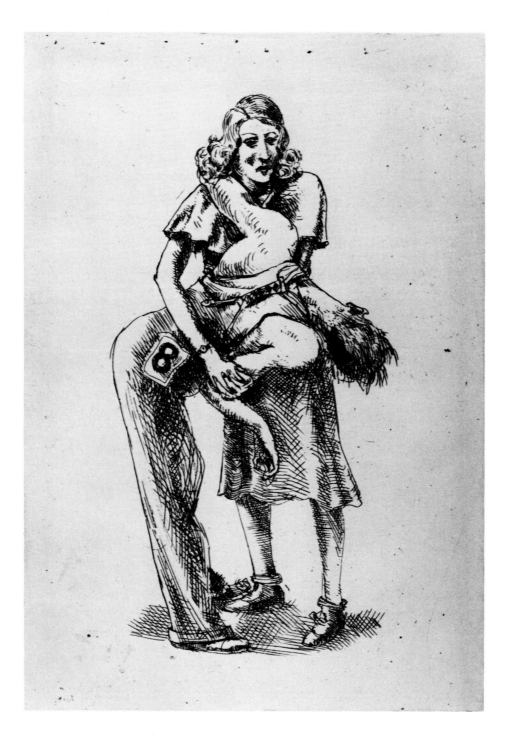

Fig. 8. *Dance Marathon*, 1931. Etching, 7 × 5 inches. The William Benton Museum of Art, University of Connecticut, Storrs.

who filled jobs offered by the new industries: secretaries, telephone operators, sales clerks.[11] With the onset of the Depression in 1929 this population also began to include unemployed men. By 1931 one-third of New York's work force was unemployed.[12] In addition, the unemployed of the nation seemed to migrate to the cities; in New York they wound up on the Bowery, where cheap flophouses offered a "bug-infested bed" for twenty-five cents a night and barber colleges cut hair for ten cents.[13] While working women spent their leisure time window-shopping and going to movies, unemployed drifters found their way into burlesque houses. On the Bowery,

admission to these theaters cost about ten cents and the doors opened at ten o'clock in the morning, so that the men could sit all day. Marsh correctly saw burlesque as one of the cheapest forms of entertainment available to them.[14]

Both burlesque houses and taxi-dance halls were located in isolated parts of the city, enabling people to participate anonymously. Unabashedly sex-centered, burlesque was possible only in a large city.[15] By 1927 it had evolved into the form Marsh would paint: an endlessly repetitive succession of chorus lines, comic bits, and stripteases.

Women could and sometimes did attend the burlesque shows, but the taxi-dance halls were "closed"—open only to men (Fig. 7).[16] Although they were ironically called "dance academies" or "dance schools," dance in-

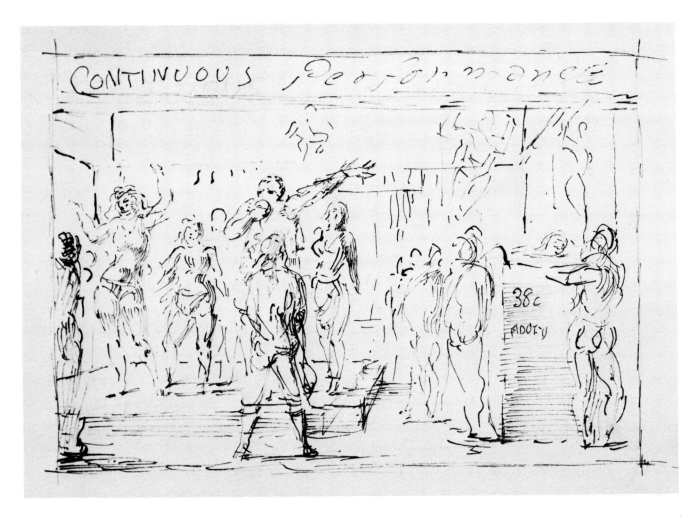

Fig. 9. *Continuous Performance*, 1945. Sketchbook no. 28. Whitney Museum of American Art, New York; Bequest of Felicia Meyer Marsh T78.1.994.

struction was one of the last things that went on in them. The men purchased rolls of tickets that allowed them to dance with any "hostess" on the floor for "ten cents a dance." The term "taxi-dancer" meant what it implied: the girls were for hire; they danced for money and spent their evenings on their feet. The phenomenon expresses the same kind of desperation inherent in the quintessential Depression event, the dance marathon, a contest in which exhausted couples would drag themselves across the floor hour after hour, hoping to win an elusive cash prize. The mood of these marathons seemed to capture the spirit of the times, "the aimless, endless movement of superfluous people around and around the country in rickety cars or on freight trains."[17]

Movies, dance halls, burlesque—these were all commercialized forms of recreation which developed to fill the needs of a new urban population. They used sex and money to bring people together, providing easy thrills and excitement for people who only temporarily shared any common interests.[18] The tawdry halls and theaters came to epitomize the disorientation and dislocation of American social life. They seemed to evoke a hysteria that lay just beneath the surface.[19] And these were the activities Marsh chose to paint; he viewed them as colorful spectacles, and was drawn to their crass glamour, their

gaudiness, their energy. He found the same appeal in the sensational tabloids of the period (another form of Depression entertainment) and in the artifacts of advertising, both of which play a part in his paintings. "Truly, the best sculpture and decoration done today, though not profound, are shop windows, and yesterday, merry-go-round horses," he said in 1939.[20]

The cheapest form of entertainment during the summer was Coney Island. First connected to the rest of the city by the subway in 1920, Coney Island by 1930 was the "empire of the nickel."[21] Drawn by its boardwalk, beaches, and sideshow amusements, New Yorkers clambered out there on hot, steamy days during the Depression, sixteen million of them each summer.[22] They laid down on the beach on newspaper and wore their bathing suits under their clothes, rather than pay for beach houses or chairs. At the sideshows, shrill barkers announced the twin prospects of sex and horror: Smoko, the Human Volcano, the tunnel of love, "Fatima, the beautiful Egyptian princess—direct descendent of Cleopatra."[23] Marsh started his treks to Coney in the early twenties, sent there for sketches by Frank Crowninshield, the editor of *Vanity Fair*, and he never stopped going. And even though his second wife, Felicia Meyer, a landscape painter, summered in Vermont, Marsh would remain in New York so that he could continue to go out to Coney. He estimated that fully one-sixth of his production came from there. "I went to Coney beach yesterday afternoon," Marsh once wrote to Felicia. "The wind was fresh and strong blow-

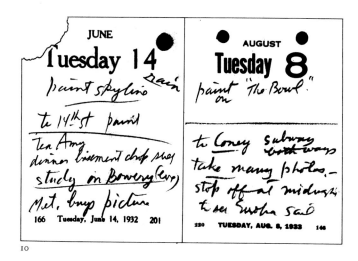

10

11

ing great whitecaps in on the seas—the sea a rich blue—The crowd as thick as ever I've seen, much to my delight. The noise of the beach could be heard for miles and there was scarce room on the sand to sit down. . . ."[24]

With its garish sideshows and rides, Coney Island was the perfect metaphor for the alienation and commercialization of urban life. It was a fantasy world aimed at mechanically inducing states of horror and fascination in its patrons. It was loud and raucous, creating an environment larger than life by presenting life in its extremes, as in freak shows. And Marsh found shows even on the beaches—musclemen exhibiting their prowess, bathing beauties lounging in the sand, tumblers and gymnasts. New York was one "continuous performance," as one of his drawings of a sideshow was entitled (Fig. 9), and Marsh sketched all of it.

Edward Laning discovered Marsh's sketchbooks in a file-cabinet drawer after the artist's death. He was not so surprised at their number—over two hundred—because he knew Marsh was rarely without a sketchpad in hand. But he was amazed to find them chronologically organized.[25] The degree to which Marsh was absorbed in systematically recording his environment *and* his own life seems extraordinary. In addition to an enormous oeuvre of nearly one thousand paintings, over two hundred prints, and hundreds of drawings and watercolors, Marsh left scrapbooks, notebooks, and calendars which recounted his whole career (frontispiece; Figs. 10, 11). In his calendars he actually totaled up how many times he had gone to Coney in a summer, how many evenings he etched or developed photographs. In his notebooks he wrote down recipes for media and how his paintings were executed. He calculated his income from both his stocks and his art. In scrapbooks he saved reviews and reproductions of his work that had appeared in magazines and newspapers (he employed a clipping agency). He even saved his business card from the *Daily News* days (Fig. 6); he kept it for thirty years.

Marsh's sketchbooks are the foundation of his art. They show a passion for contemporary detail and a desire to retain the whole of his experience. He recorded everything—locations, costumes, signs, postures, even the weather ("hot as hell" on June 22, 1931). A pad used on a day he went to Coney Island might begin with sketches on the subway or ferry (depending on how he was traveling). Once there, his eye and hand delighted in the postures and gestures of people lounging about in the sand (Figs. 16, 139, 141). At the Bowery, his eye was attracted to the bums (Figs. 17, 87). Like the beach figures, these were men apart from the daily work world. They idled about in a variety of poses beneath the tracks of the El, its shadows accentuating the creases and wrinkles in their overcoats and faces. Marsh took down the messages and designs of advertisements, posters, and street signs, with notes describing how the lettering appeared—slanted, italic, yellow—where reflections were (Fig. 68), where eye level was, where he was standing, whether the light was electric. The sign in *Why Not Use the "L"?* is found twice in his sketchbooks (Fig. 107) and the buckwheat-

Fig. 10. Calendars, 1932–33. Reginald Marsh Papers, Archives of American Art, Smithsonian Institution, Washington, D.C.
Fig. 11. Notebook no. 4, 1934. Reginald Marsh Papers, Archives of American Art, Smithsonian Institution, Washington, D.C.
Fig. 12. Bathing suit and beach chair, 1935; sketchbook no. 61. Dress and placard carrier, 1934; sketchbook no. 121. The Metropolitan Museum of Art, New York; Bequest of Felicia Meyer Marsh.
Figs. 13, 14. Sketches for *Why Not Use the "L"?*, 1930. Sketchbook no. 179. The Metropolitan Museum of Art, New York; Bequest of Felicia Meyer Marsh.

12a

12b

12c

13

14

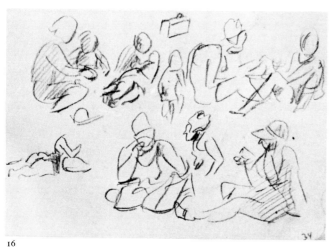

15

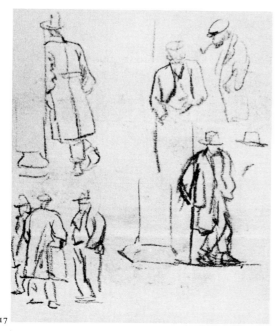

16

17

Fig. 15. Theater details, c. 1929. Ink on paper, $4\frac{1}{2} \times 6\frac{1}{2}$ inches. Whitney Museum of American Art, New York; Bequest of Felicia Meyer Marsh T78.1.809.
Fig. 16. Beach figures, 1930. Sketchbook no. 146. The Metropolitan Museum of Art, New York; Bequest of Felicia Meyer Marsh.
Fig. 17. Bowery figures, 1931. Sketchbook no. 63. The Metropolitan Museum of Art, New York; Bequest of Felicia Meyer Marsh.

pancake ad used in that painting was sketched from two vantage points (Figs. 13, 14). Details for *Pip & Flip*, such as drawings of Major Mite and the Twins from Peru, are found in three different sketchbooks; there also exists a thumbnail sketch for the entire composition. In scores of other sketches, he put down the baroque details of the burlesque theaters, their draperies, columns, and cupids (Fig. 15).

The early sketches are often obscure about facial expressions, awkward in the positioning of hands and feet. Yet there is enough there to tell whether these are women in the chorus line at the Gaiety Burlesque or the exuberant dancers at the Savoy nightclub in Harlem. The curved outlines blur costumes and figures together but convey characteristic movements and energy—a sense for the gestures of the crowd, the deshabille of a hot summer day at the beach. Details then become props to delineate the setting in the manner of a cartoonist.

Were his sketchbooks not enough, Marsh's diaries and photographs would illustrate the close connections between his paintings and their sources. Invariably, he began his paintings after visiting a place. *Ten Cents a Dance* (Fig. 20), for example, was based on many visits "to Cosmo. dance hall." According to his calendar for 1933, he went to the dance hall on April 18 and three days later started the painting he originally called "Hostesses." He returned there on May 19, May 30, and June 15. In a small sketchbook he drew the women lounging about in various states of fatigue, boredom, and languid seductiveness. Then in red chalk he worked up larger drawings of the women, sometimes just their bodies (Fig. 21). In the painting, the women are closely organized in back of the rail to project the varieties of moods and attitudes present in the sketches. Three years earlier, in 1930, Marsh had illustrated a story for *The New Yorker* about dance hostesses, called "Shadowland" (Fig. 22). The vivacious blond in *Ten Cents a Dance* recalls Zelda, one of the hostesses in that story, who wears a "tight-fitting red silk [dress] which, cut low and without sleeves, showed off her figure advantageously."[26]

By the early 1930s, Marsh's passion for documentation led him to photography.[27] His photographs have usually been seen as a generalized system of note-taking, with no particular relationship to the paintings. But careful comparison of photographs taken in 1933 with two major works of that year, *Lifeguards* and *Smoko, the Human Volcano* (Figs. 123, 127), reveals that some of the figures and groups in the photographs were transferred directly to the paintings.[28]

Lifeguards and *Smoko, the Human Volcano* were first conceived toward the end of August 1933. Earlier that month, in fact the day after he returned from a trip to Europe, Marsh was off to Coney Island, bringing a camera with him and, according to his calendar (Fig. 10), he took "many photos." Later that month, on August 25, he went out to Jones Beach (Figs. 18, 19). And on August 26 he was again at Coney. In early September he began two paintings, one called "Beach" or "Jones Beach," the other called "Sideshow." From his sketchbooks and di-

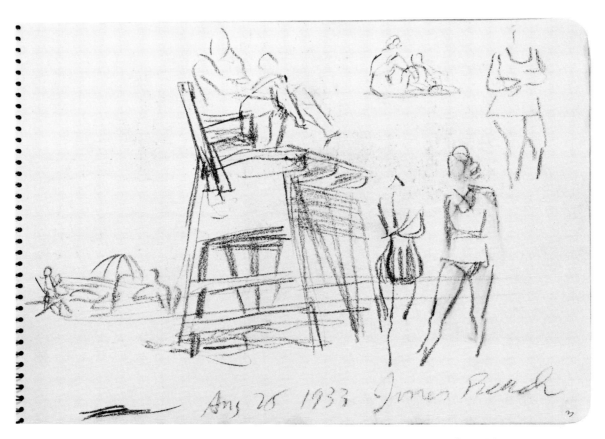

Fig. 18. Jones Beach, 1933. Sketchbook no. 83. The Metropolitan Museum of Art, New York; Bequest of Felicia Meyer Marsh.

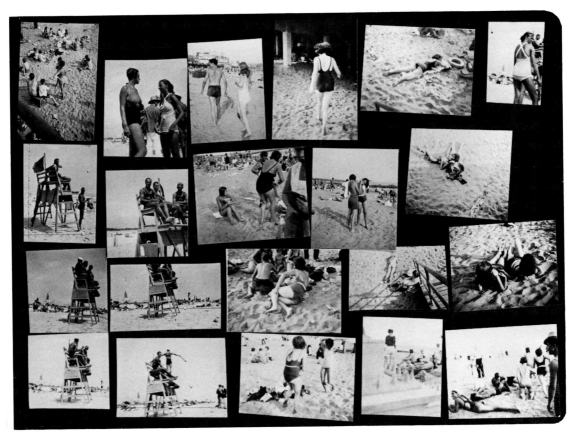

Fig. 19. Photograph album, 1933. Print Archives, Museum of the City of New York; Bequest of Felicia Meyer Marsh.

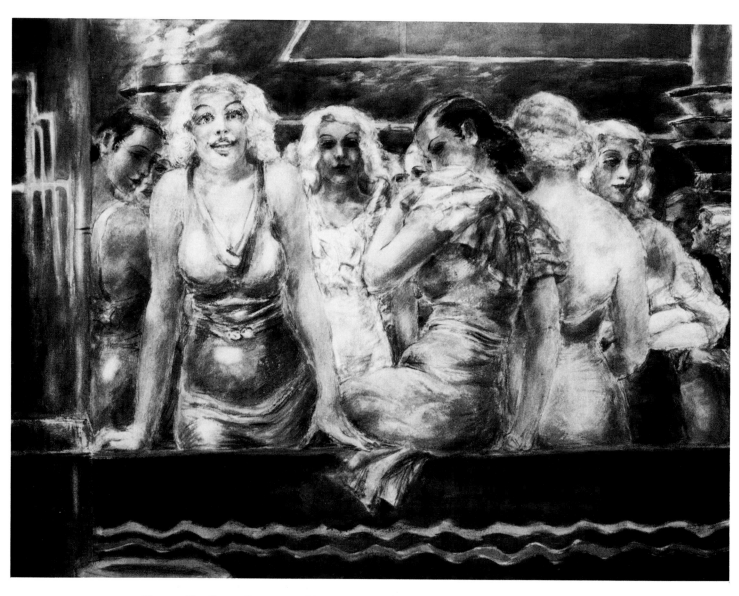

Fig. 20. *Ten Cents a Dance*, 1933. Tempera on panel, 36 × 48 inches. Whitney Museum of American Art, New York; Bequest of Felicia Meyer Marsh 80.31.10.

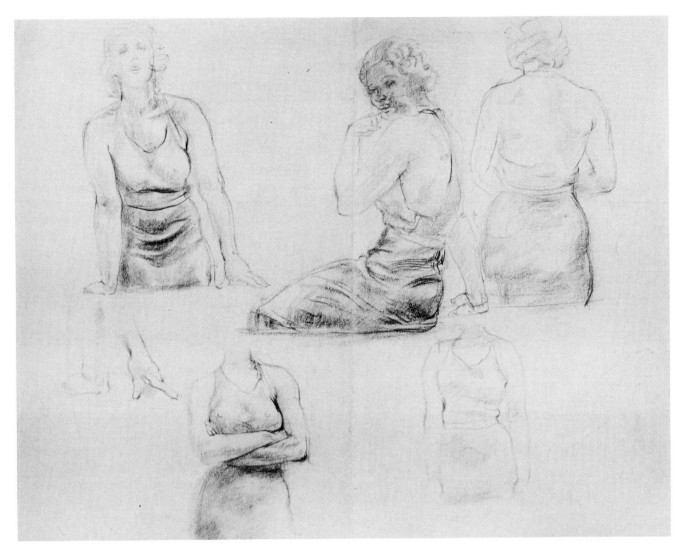

Fig. 21. Studies for *Ten Cents a Dance*, 1933. Chalk on paper, 16 × 21 inches. Whitney Museum of American Art, New York; Bequest of Felicia Meyer Marsh T78.1.766.

aries, it is likely that *Lifeguards* is actually the painting of Jones Beach and "Sideshow" became *Smoko, the Human Volcano*. A wonderful series of snapshots (Fig. 124), some loose and others in a Fotofolio, shows each of the groups that finally comprised *Lifeguards*—one woman fixing another's hair, the acrobats at the left of the composition, the two women with their arms around each other in the center, and the woman at the bottom right lying on her stomach with her feet up. In a four-part sketch, Marsh played with each of these groups to find a successful arrangement (Fig. 125). In the painting, the central pyramidal form leading up to the lifeguards is accentuated by the densely packed foreground figures.

For *Smoko* Marsh both made specific sketches (Fig. 128) and took photographs of the signs and characters (Fig. 129). A set of snapshots records Smoko, with his suspenders and tie, the barker, the lady performer, and the deformed midget with a headband in her hair and her arms crossed in front of her. These photographs were not used quite as directly as those for *Lifeguards*. Instead, Marsh chose representative positions and poses from the photographs that capture the spirit of the sideshow at-

traction. Nonetheless, the painting is still so specific that the former owners of the work purchased it precisely because they remembered the characters from their youth at Coney Island.

This kind of documentary specificity is a crucial element in Marsh's art. It ties his work securely to the thirties, as do the dated headlines and the price signs he painted into his compositions. But Marsh's art reflects the social reality of his time in less literal ways as well. The compositions he constructed, the colors he used, the agitation of his forms—all serve to evoke a kind of psychological reality; they reflect the excitement, alienation, and restlessness of the new commercial environment.

For example, whatever figures Marsh may have appropriated from photographs, their integration in the painted composition is telling. The snapshots for *Smoko* present an immediate image of the sideshow, but with little drama. They are candid and, seen in daylight, the sideshow and its characters appear far more innocent and youthful, less exotic. Like the sketches in Marsh's pads, they record the artist's wanderings in and around these sites, taking pictures from different angles. But for the composition Marsh presented the sideshow to the spectator head-on. The signs for Smoko and the Orientalist Supreme are brought up close to the picture surface and shown frontally. The performing lady is placed centrally

and the space in front is filled with the busy crowd, looking at the show or aimlessly about them. These figures are shown from the chest up. The eye level assumed for the painting is that of a person in the crowd. Finally, there is a break in the crowd just in front of the main event. This is the spectator's presumed and preferred position—the observer gets the best seat in the house.

The emotional character of Marsh's subjects is often intensified by color. In his beach paintings, such as *Lifeguards* (see inside back cover), and *Hot Afternoon*, the blond, orange, or ochre tones resonate with the sun-filled beach. The grisaille coloration of *Holy Name Mission* bespeaks the drab and grim realities of life on the Bowery. In *Smoko*, as in many of Marsh's paintings of sideshows (see back cover), the predominant red in the background conveys the made-up thrills and horrors of the sideshow. Indeed, Marsh's reds and greens are often garish and gaudy. Lurid and loud, they scream at the observer, much like the titles of his paintings or the electrical lighting of advertisements.

Edward Laning long ago compared the style of Marsh's paintings to that of the commercial world itself. He described this world as "an endless flow of free images which have no fixed locus but are woven through the entire physical fabric of our lives, in papers and magazines, on walls and billboards, in the air as skywriting, in electrical displays and in shadows projected on screens."[29] He noted that Marsh's art has the same feeling of transience, the same flickering cast of images, emphasizing "motion, change and novelty."[30] Kenneth Hayes Miller, Marsh's teacher and friend, had even said that Marsh's paintings were not meant to be seen in the singular, but rather in the plural.[31] Seen together, like frames from a movie, Marsh's paintings project a cinematic vision of the city, a city whose surface was always shifting. Even his way of pasting the contacts of his photographs into albums seems to maintain this cinematic flavor (Figs. 19, 73), as does his habit of working on several paintings at once.

The analogy with movie frames also expresses the sequential, linear character of movement within Marsh's paintings. "One reads his paintings almost as one would watch an unwinding newsreel," wrote Matthew Baigell, referring to the lack of a single focal point in the compositions.[32] The eye keeps moving across the surface, reading signs and details. Compositional arrangements, elliptical or oblique, further accentuate the crossways direction—the same direction initially found in the two-page spreads Marsh did for *The New Yorker*, in which the action often unfolded across the page (Figs. 7, 24, 135). In Marsh's paintings, this surface flow is encouraged by the compressed space in which the figures perform. Marsh always preferred a relief-style arrangement of figures—a "frieze," as Lloyd Goodrich described it, in which the figures are lined up in front of the background.[33] Not only is the pictorial stage shallow, but spatial recession tends to be arrested by the bright colors and signs which cover the background. In *Pip & Flip* (Fig. 130), the packed figures press urgently against one another. They are forced forward toward the picture plane by the signs which loom, large and strident, behind them. They seem to be wedged between the signs and us. The effect of this is to dissociate the figures from the background, which functions like a flat stage set (Marsh did in fact paint backdrops early in his career). Marsh's people cannot make themselves comfortable—physically or psychically—within the raucous urban environment.

This dissociation of figures from setting is also apparent in compositions in which characters face out of the painting, hardly relating to their surroundings (Figs. 20, 92). "His characters do not live in their environments but usually exist in front of them," observed Matthew Baigell.[34] By studying the process Marsh used to construct his painting *Twenty Cent Movie* (Fig. 65), one can see how this sense of alienation developed. *Twenty Cent Movie* is a vibrant painting of men and women strutting in front of the Lyric Theater. But in at least two sketches, he worked up the composition with only the barest hint of the figures (Figs. 66, 69; see also Figs. 51, 80). Other sketches feature the movie posters, statues, and ticket window (among other things) as individual subjects, carefully scrutinized (Figs. 67, 68). Some are done over with more or less detail from nearer or more distant viewpoints. It appears from these sketches that Marsh approached the setting first, putting in details as it became clarified. Finally, the figures were added. The finished painting retains the sense of figures and setting as two distinct elements, connected only by virtue of the performance in which they participate.

As little interaction as the figures have with their environment, they interact even less with each other. What interested Marsh was not the individuals in a crowd, but the crowd itself—the urban masses brought together randomly on subways, at the beaches and sideshows. Marsh detailed the world his figures inhabited, but left the inhabitants anonymous.[35] In their density and picturesqueness, they recall the crowds in the movies of Preston Sturges or Frank Capra.[36] They project an "emotional sameness."[37] As Thomas Garver pointed out, Marsh drew a collective portrait, defining these crowds by the "cherished banalities" of their world—the newspapers they read, stories that interested them, the wrappers from the candy bars they ate, the movies they went to see.[38] And even his individual figures function as types—the city slicker, the fashion plate (Figs. 38, 40). Like crowds, they personify the city in the abstract.[39]

The typecasting of Marsh's characters was in part the result of the new popular culture propagated by movies and radio, media that created a uniformity of style and taste. From this uniformity, popular icons emerged to dominate the world of the thirties, and no icon was more dominating than that of the Hollywood movie star. Marsh was keenly aware of the power of this cultural symbol—in *Twenty Cent Movie*, the poster of the movie queen projects out and over the woman beneath her (see also *Paramount Pictures*, Fig. 70). The artist himself haunted the movies.[40] Is it a coincidence that days before

starting the painting *Star Burlesk*, which features a large, golden burlesque queen, he went to see the movie *I'm No Angel*, featuring another queen—Mae West? Many of Marsh's women look like the screen heroines of the time: he painted them the way they painted themselves. Packaged to present the American male's ideal of femininity, they were equal parts baby-doll, siren, and bombshell. Compare the faces on screen-magazine covers in the thirties (Fig. 23) to the faces in *Ten Cents a Dance, Hudson Bay Fur Company*, or *Star Burlesk* (Figs. 20, 43, 82). This is the platinum blond of the thirties, Jean Harlow or Mae West—golden-haired saints (or, rather, yellow-haired ladies with acquired attributes), bottled blonds with painted lips. These are women who bought cosmetics, who made themselves up to look like Jean Harlow, and wound up looking like the crowd. And even when they are not contemporary beauties, they are dressed in cheap Fourteenth Street versions of the latest fashions.

It was advertising that made the movie-star type so omnipresent and irresistible.[41] The stars were brand names, popularized by billboards and hundreds of studio photographs. And Marsh's women are advertisements too, as eye-catching as the new neon lights, as colorful and evanescent, as bold and contrived. They embody the same commercial energy, brightness, and capaciousness as the city did. Loud and brassy, they personify the city.

In effect Marsh often uses the women in his paintings as he does advertising verbiage: to lure the spectator into the image. "Go over to the rail and wait," says the seasoned dance-hall hostess to the newcomer in the 1931 movie *Ten Cents a Dance*. "And while you wait, you can advertise." That is exactly what the blond hostess does in Marsh's painting of the same title (Fig. 20). In paintings like *Twenty Cent Movie, Pip & Flip* (Figs. 65, 130) and *Ten Cents a Dance*, the spectator assumes the customer's position. Titles, signs, and seductive characters directly confront the observer and urge him to participate.

Marsh's paintings manipulate the devices of the commercial world—sex, humor, confrontational questions. The spectator is teased into the image with a headline like "Does the Sex Urge Explain Judge Crater's Mysterious Disappearance?" (from *Why Not Use the "L"?*). Grabbed by the question, he gets closer to read more and is forced to enter the painting's reality, its time and place. The paintings become a part of the social reality they depict.

Fig. 22. Illustration for the story "Shadowland," from *The New Yorker*, October 11, 1930.

Fig. 23. Cover of *Modern Screen* magazine, 1932 (not by Marsh).

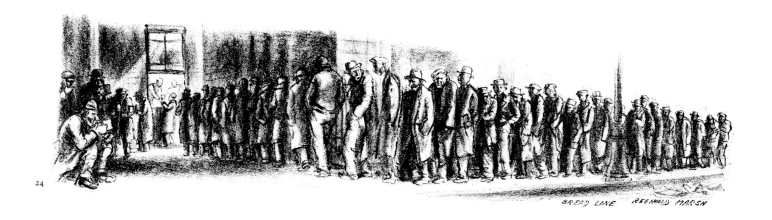

24

BREAD LINE REGINALD MARSH

THE INNER DRAMA

The social reality Marsh depicted was decidedly lower class—at odds with his own background, education, and economic position. In 1930 the artist was thirty-two years old. It was a year after the stock-market crash and he had taken a loss of ten thousand dollars, yet still managed to show earnings of over five thousand dollars from stocks alone.[42] Two years earlier he had inherited some of his grandfather's money. In other words, Marsh was hardly starving during the Depression. Comfortable all his life, often dressed in Brooks Brothers suits, he was worlds removed from the people he painted who traveled out to

Coney Island on hot summer days. Yet he was fascinated and drawn to them. At one point he indicated that he felt the lower classes were more interesting to paint: "well bred people are no fun to paint."[43]

But Marsh was significantly selective in his "lower-class" types: throughout his work certain characters constantly reappear—Bowery bums, burlesque queens, musclemen, and bathing beauties. Sources for these images in Marsh's art predate the thirties: he sketched an interior of a movie theater in his childhood diary (Fig. 2), drew chorus girls while a student at Yale (Fig. 4), and sketched the tramps lying by the side of the road while he was in Paris (Fig. 25). These are the kinds of subjects and figures that stand out most forcefully in his art.

Perhaps Bowery bums and Jean Harlows do personify the thirties. But if their choice was socially valid it was also personally motivated. Nothing reveals this underlying layer of meaning more than Marsh's work process.

Fig. 24. "Bread Line," from *The New Yorker*, November 22, 1930. Clipping in scrapbook no. 5. Reginald Marsh Papers, Archives of American Art, Smithsonian Institution, Washington, D.C.

Fig. 25. Tramps in Paris, 1926. Sketchbook no. 2. The Metropolitan Museum of Art, New York; Bequest of Felicia Meyer Marsh.

25a

25b

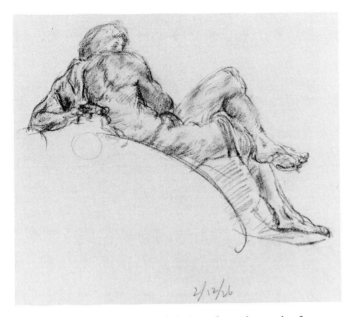

Fig. 26. Sketch of Michelangelo's *Day*, from the tomb of Giuliano de' Medici, 1926. Charcoal on paper, 9 × 11¾ inches. Whitney Museum of American Art, New York; Bequest of Felicia Meyer Marsh 80.31.75.

Fig. 27. Sketch after Delacroix's *The Death of Sardanapalus*, c. 1938. Sketchbook no. 47. The Metropolitan Museum of Art, New York; Bequest of Felicia Meyer Marsh.

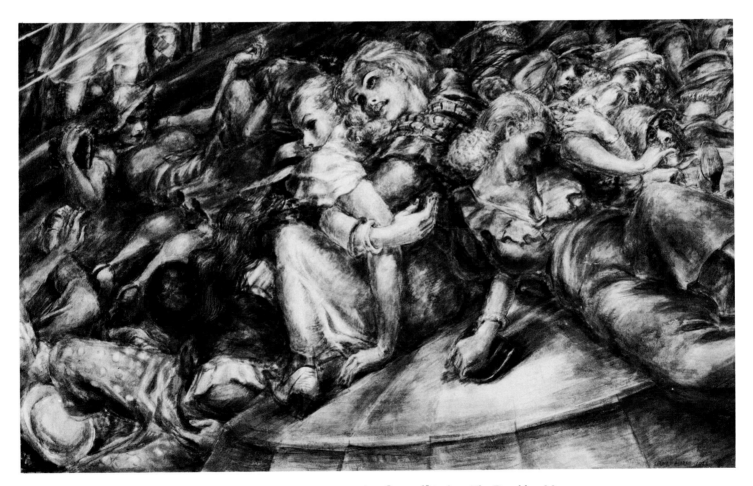

Fig. 28. *The Bowl*, 1933. Tempera on panel, 35⅞ × 59¹⁵⁄₁₆ inches. The Brooklyn Museum; Gift of William T. Evans.

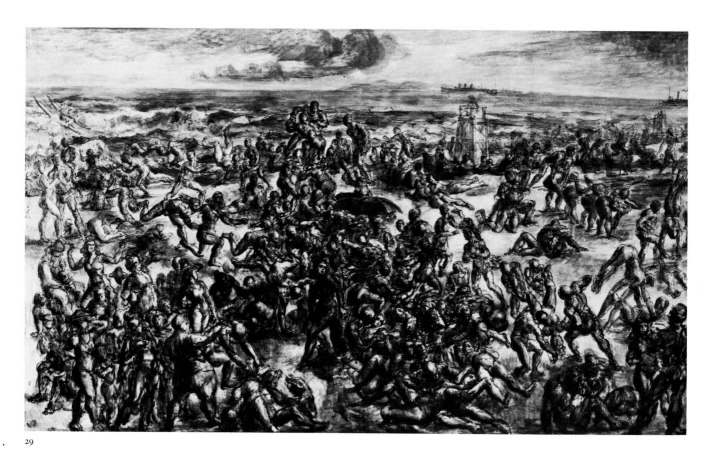

29

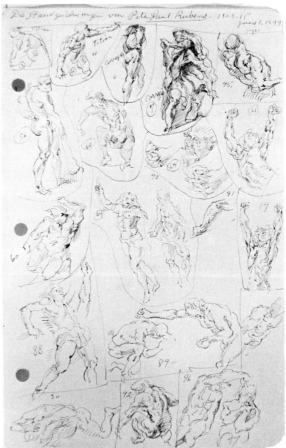

30

Fig. 29. *Coney Island Beach*, 1939. Tempera on panel, 29½ × 49½ inches. Collection of Marjorie and Charles Benton.

Fig. 30. Sketches after Rubens, 1944. Ink on paper, 8½ × 5½ inches. Whitney Museum of American Art, New York; Bequest of Felicia Meyer Marsh 80.31.141.

Fig. 31. *Coney Island*, 1936. Tempera on panel, 60 × 36 inches. Syracuse University Art Collections, Syracuse, New York; Purchase.

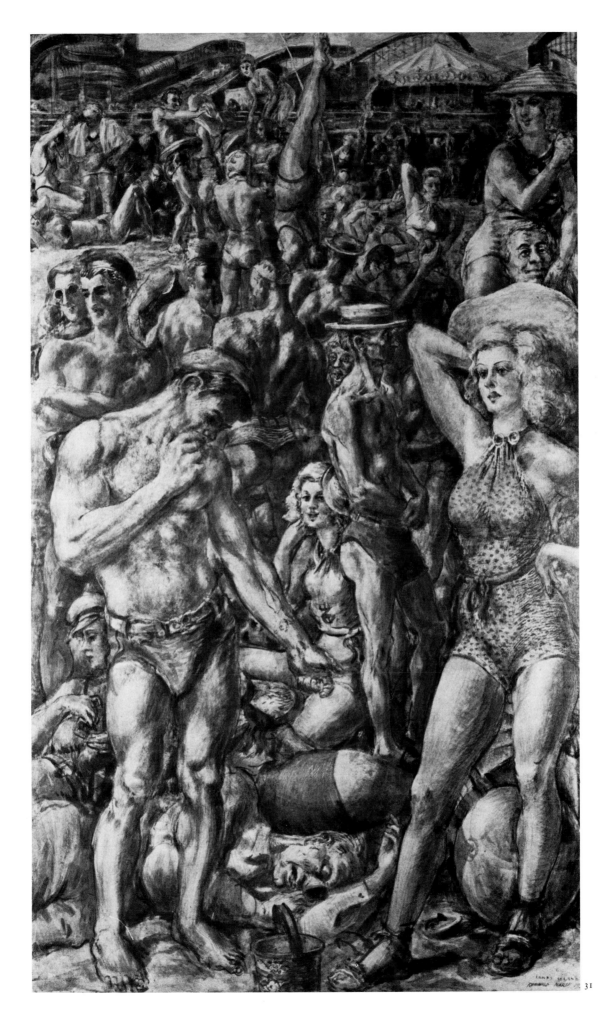

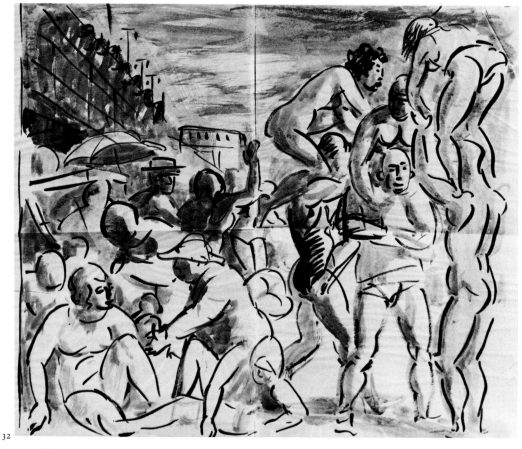

Fig. 32. Study for *Coney Island Beach*, 1934. Ink on paper, $13\frac{1}{2} \times 16\frac{7}{8}$ inches. Whitney Museum of American Art, New York; Bequest of Felicia Meyer Marsh T78.1.27.
Fig. 33. Study for *Coney Island Beach*, 1934. Ink on tracing paper, $10\frac{5}{8} \times 10$ inches. The William Benton Museum of Art, University of Connecticut, Storrs.

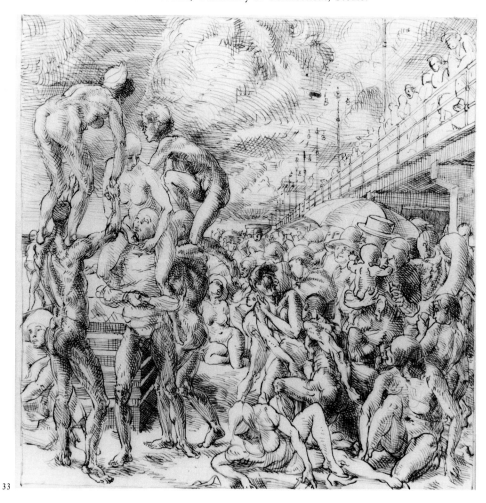

Fig. 34. Sketch after Rubens' *Diana Surprised by Satyrs*, c. 1928. Chinese ink and pencil on paper, 11 × 8½ inches. Whitney Museum of American Art; Bequest of Felicia Meyer Marsh 80.31.111.
Fig. 35. *Coney Island Beach*, 1934. Etching, 10 × 10 inches. The William Benton Museum of Art, University of Connecticut, Storrs.

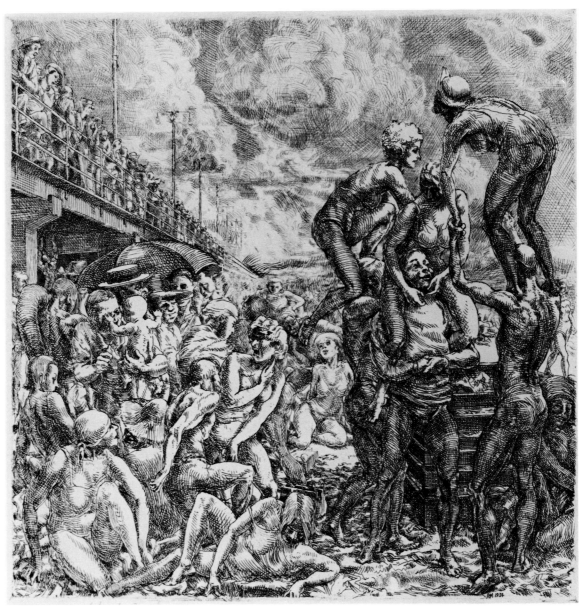

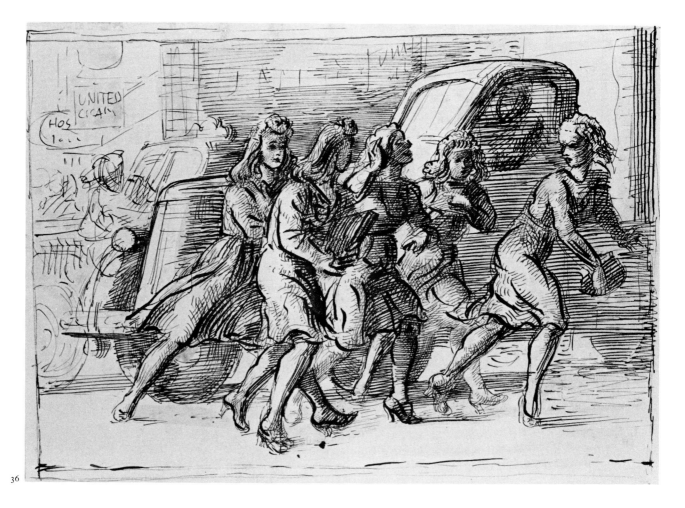

36

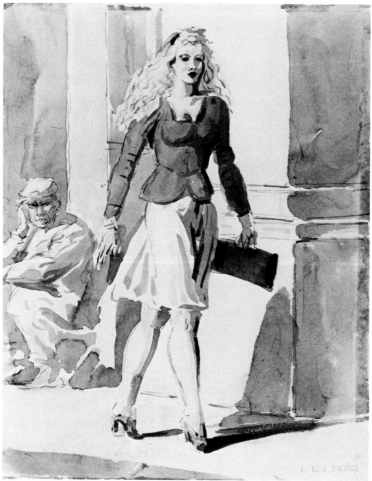

Fig. 36. Study for *Dead Man's Curve*, 1940. Chinese ink on paper, 6½ × 9⅝ inches. Whitney Museum of American Art, New York; Bequest of Felicia Meyer Marsh 80.31.80.
Fig. 37. Seated man and walking woman, 1943. Watercolor and Chinese ink on paper, 10⅜ × 8½ inches. Whitney Museum of American Art, New York; Bequest of Felicia Meyer Marsh 80.31.92.

37

As we can see from his sketchbooks and prints, he returned to the same places over and over again (Figs. 92, 93), often took the same viewpoints in sketches and photographs (Figs. 139–142), and even made photographs which recapitulate the compositions of earlier paintings (Figs. 43, 44, 70, 71).[44] Thus, long after he had first recorded an image he continued to see it. Figures and subjects stayed with him and their almost compulsive repetition suggests something beyond the realm of the documentary.[45] His 1931 painting *Hot Afternoon* (Fig. 147), probably of the Atlantic City beach, and his 1939 painting and print of Coney Island (Figs. 29, 148) are, despite coloristic and stylistic differences, spiritually related. All three scenes concentrate on masses of interlocking and weaving bodies—and recall an early linocut in a primitive modernist style that Norman Sasowsky entitled *Resurrection* (Fig. 146).[46]

The title *Resurrection* may not be Marsh's own, but it accords with the visual character of the linocut and with Last Judgment scenes by the Old Masters—allusions which continue to inform the later paintings and the print. If Marsh's documentary authenticity is compromised both by the selectivity and the repetition of his imagery, it is even more compromised by his involvement with the Old Master tradition. There is no doubt that much of Marsh's engagement with the Old Masters was technical, just as there is no doubt that he was not the only artist interested in the Renaissance during the 1930s.[47] But unlike his contemporaries, Marsh's affinity for the Old Masters may have originated in childhood. His father's studio was decorated with reproductions after Tintoretto and Rubens.[48] At Yale he studied the history of art. After his trip to Europe in 1925 (which included a visit to Florence), he studied with Kenneth Hayes Miller at the Art Students League, a teacher noted for his devotion to the Old Master tradition. Miller's idols were Titian, Rubens, and Michelangelo. He and Marsh studied these painters together and would often go to the Metropolitan Museum of Art. All through Marsh's life, he made copies in his sketchbooks of Old Master paintings (Figs. 26, 27, 30), and his own published book, *Anatomy for Artists* (1935), is based on drawings made after Old Master figures.[49] He never ceased to love and study the Old Masters.

One of the things that intrigued Marsh most about Renaissance and Baroque art was the painters' ability to organize large figure groups—crowds of people—against architectural backdrops or landscapes to achieve monumentality and stability.[50] Since Marsh was also attracted to large figural scenes, emulating the Old Masters was a means to structure his own works. In paintings and prints like *Chatham Square* or *Tattoo—Shave—Haircut* (Figs. 88, 92), he used the pillars of the El or the barber's poles to separate the men and punctuate their postures. Moreover, while a tendency to relief style may have originated in cartoons, it was enriched by his study of Renaissance compositions, such as those of Raphael.

But Marsh was especially interested in tangled bodies,

wrestling men, and writhing women, elements he found in abundance in the work of Michelangelo and Rubens. When Marsh looked at the contemporary world, it reminded him of the masters: "I like to go to Coney Island because of the sea, the open air, and the crowds—crowds of people in all directions, in all positions, without clothing, moving—like the great compositions of Michelangelo and Rubens."[51]

Ultimately, Marsh allowed his devotion to the Old Masters to transform the reality of the 1930s;[52] he began to introduce into his images the character of the past. Sometimes it was a non-specific sentiment or visual orientation that evoked these grand compositions, a Last Judgment or a Rape of the Sabine Women that seemed to inform the crowds at the beach or on Fourteenth Street. The general emphasis on full-length bodies, detailed muscles, broad movements, and multiple figures gave his art a semi-heroic scale. The chains of people in various stages of entanglement at the beach (Fig. 118) might recall a Flemish Kermess, a village scene of peasants drunk with life, holiday, and nature. (Rubens' *Kermess* was one of the first paintings he copied.) The jumble of people precipitously falling forward, out, and down the street in *In Fourteenth Street* (Fig. 72) echoes the disoriented characters of a Last Judgment. The woman walking under the ladder, somehow inviolate, wears her hat as if it were a halo (Fig. 40). And at the far end, a cripple is almost trampled, like some unfortunate reprobate soul. Venuses and Adonises walk the Coney Island beach (Fig. 31); deposed Christs collapse on the Bowery (Fig. 93). There are Michelangelesque figures at the Bowl at Coney Island (Figs. 26, 28). The ceiling of Steeplechase Park resembles the ceilings of German Baroque cathedrals, with their rings of exultant angels. On stage at the New Gotham, the burlesque queen (Fig. 51) covers herself in the manner of a classical *Venus pudica*.

Sometimes Marsh's use of the Old Masters is quite specific, as in the evolution of the 1934 print *Coney Island Beach* (Fig. 35) and his painting of the same year (Fig. 118), which was made by tracing a projection of the print. An early drawing (Fig. 32) for the print lacks the pair to the left of center, a woman pulling away from a man. It is added to a later drawing, and not originally as a man and woman, but as a satyr and man (Fig. 33). (Marsh did a few drawings, after Rubens, of satyrs [Fig. 34].) In the painting, Marsh added details of the tumultuous present—Nestlé candy wrappers and a Yiddish newspaper (Fig. 118).

The past and the present constantly collide in Marsh's art. Why was there no apparent contradiction for Marsh in combining these Old Master visions with what he saw around him? Perhaps because he was drawn to both by the same thing: in both places he found sexually charged images, idealized and inaccessible figures of beauty and sex. Burlesque queens in their theaters re-created states of ecstasy for their worshiping patrons. Pinup movie stars were adored like the icons of the past.

Marsh's art is about sex; even Kenneth Hayes Miller

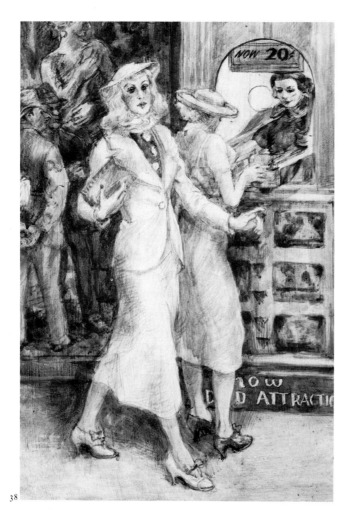

38

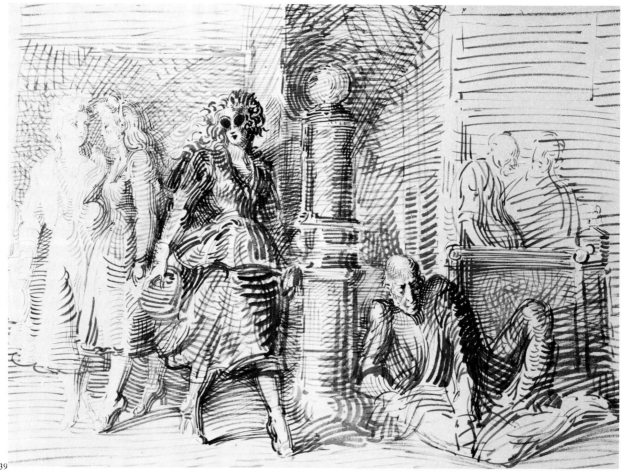

39

Fig. 38. Detail of *Twenty Cent Movie*, 1936 (see Fig. 65).
Fig. 39. *Sidewalk Scene*, c. 1950–53. Chinese ink on paper, 22 × 30 inches. Collection of Marjorie and Charles Benton.

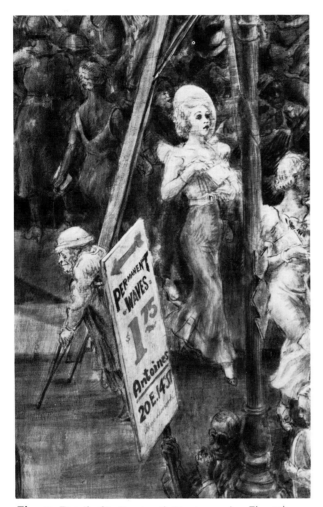

Fig. 40. Detail of *In Fourteenth Street*, 1934 (see Fig. 72).

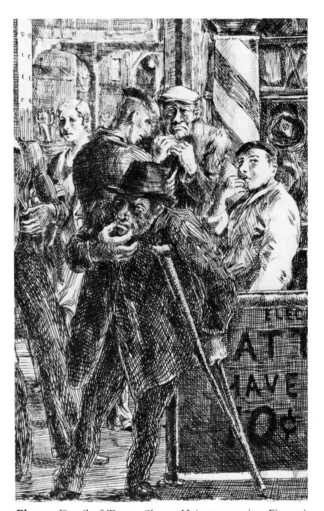

Fig. 41. Detail of *Tattoo—Shave—Haircut*, 1932 (see Fig. 92).

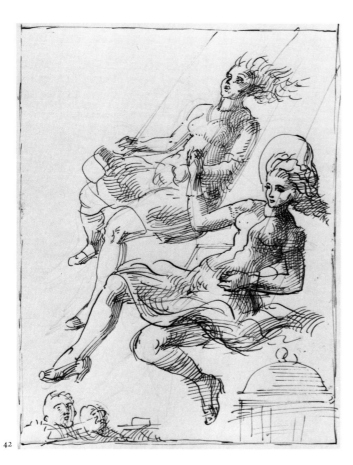

Fig. 42. Study for *Swinging Chairs*, c. 1943. Ink on paper, 11 × 8½ inches. Whitney Museum of American Art, New York; Bequest of Felicia Meyer Marsh 80.31.71.
Fig. 43. *Hudson Bay Fur Company*, 1932. Tempera on canvas mounted on panel, 30 × 40 inches. Columbus Museum of Art, Ohio; Museum Purchase: Howald Fund.
Fig. 44. *Fourteenth Street*, c. 1939. Photograph. Print Archives, Museum of the City of New York; Bequest of Felicia Meyer Marsh.

had told him that. "You are a painter of the body," he said. "Sex is your theme."[53] It is obvious in the puns and titles, signs and movie marquees that enliven his pictures. "The Joys of the Flesh" beckon from the movie marquee in *Twenty Cent Movie* (Fig. 68). "Mrs. Jack Legs Diamond" he puns across the top of *Pip & Flip* (Fig. 130), alluding to the long-legged ladies front and center in the painting. (In the drawing [Fig. 131] for the painting, one can see how he purposefully arranged the legs this way. He made the legs of the four women parallel in a repetitive pattern that echoes Radio City Music Hall's Rockettes or the parallel-leg rhythms of dance numbers in Busby Berkeley's 1930s movies.) *Dead Man's Curve* (Fig. 36) does not refer to the shape of a road. In some of Marsh's earliest linocuts, the sexual content is obvious and primitive, as in an Easter greeting card of a man and woman making love. Much later, in a book made clearly for his own amusement, Marsh hints at one underlying fantasy that runs through his work. Woman after woman is shown parading by, barely clothed. Shoeless, they still walk as if in high heels. Bosoms are hardly covered; hair flows. These are images of unbridled sexuality; in a few of them men appear in the background, watching, as in a drawing of 1943 (Fig. 37). And in some of these images, women expose their behinds to the observer, a lascivious invitation.

Marsh was drawn to the beaches, to the streets, and to the burlesque of New York because he was drawn to these women. He was seduced into painting New York because these women seduced him. Look, for example, at the painting *Hudson Bay Fur Company* (Fig. 43) and a photograph of a like subject, taken by Marsh some years later (Fig. 44). While the painting employs an angle close to the photographic view—that of a passerby (no doubt male) who happened to look up while walking down the street—the changes are significant. In the painting, the models are brought closer and loom larger. And one model turns to the viewer. Purely Marsh's fantasy now, she looks down and opens her coat to reveal buxom breasts. "Country Gentlemen Lured by Slick City Women" he wrote on a movie marquee in one of his drawings.

Marsh was probably drawn to Old Master art because he saw in it the same lusty sexuality. Michelangelo, Rubens, and Delacroix did more than provide models of composition and technique: they painted images of large, ideal, heroic, and often quite erotic women, like Delacroix's *Liberty Leading the People* with one breast bared.[54] In the art of the past, Marsh found women who were emotionally more in keeping with his own themes. His rejection of modern art was based on its lack of sexuality, an emptiness he felt in its forms and colors, devoid of either feminine or masculine identification. Marsh objected to the sterility of modern art. He wanted muscles, flesh, and bodies in painting. His ladies on the beach were powerful, sexual Sabine women. His attraction to Coney Island can be understood as an attraction to a fantastic vision of sexuality. The beach is perceived as a

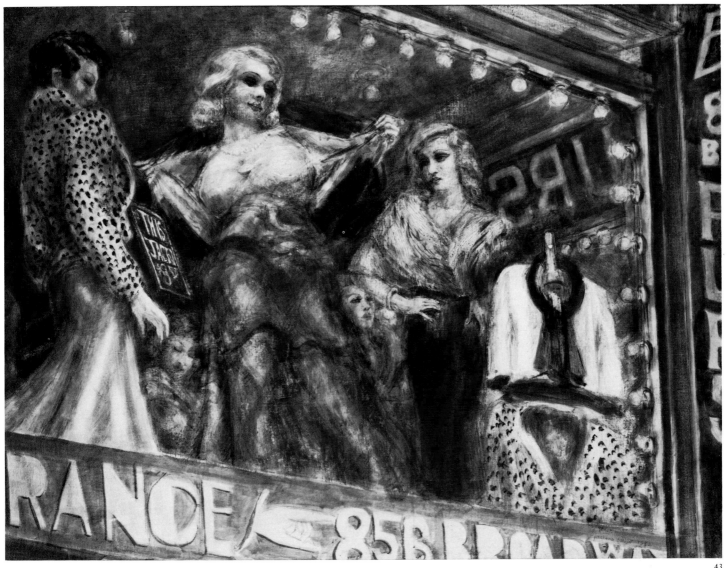

43

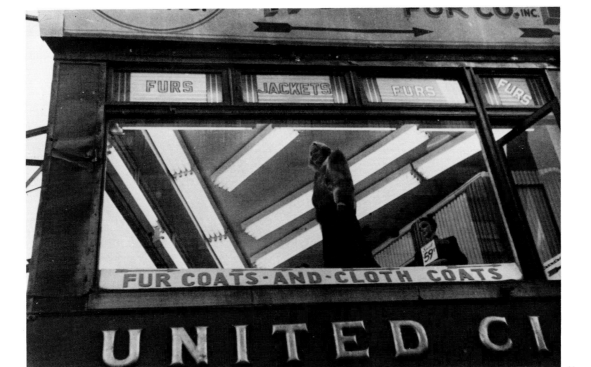

44

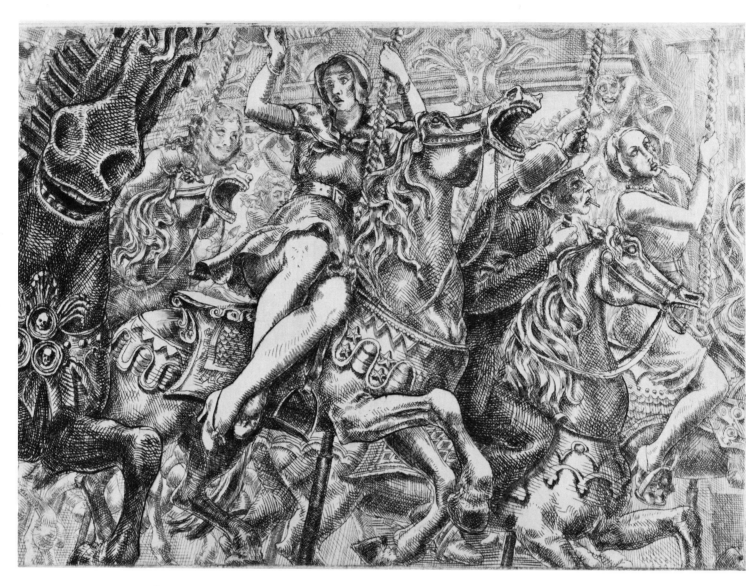

Fig. 45. *Merry-Go-Round*, 1930 (restruck 1969). Etching, $7\frac{7}{8} \times 9\frac{7}{8}$ inches. Whitney Museum of American Art, New York; Original plate donated by William Benton 69.97c.

site of tropical abandonment. Divorced from the day-to-day routines of work and domestic chores, shorn of clothing, people come closer to their natural state.

But Marsh's vision of sexuality was exactly that—a vision—and a vision peopled by recurring characters: bathing beauties and burlesque queens, Bowery bums and burlesque patrons, musclemen. As lusty and inviting as his women may seem, they are, like pinup queens or saints in ecstasy, symbolic forms—fantastic projections, usually out of reach.[55] Except in the beach scenes, men and women often remain separated in his paintings. Caught in a permanently disconnected relationship, they rarely touch.

In *Hudson Bay Fur Company* (Fig. 43), the women are seen from below, through the window glass. Whether on the carousel, on steeplechase swings, on the boardwalk, or on the burlesque stage, Marsh's women are often aloft and above. They go round and round on merry-go-rounds or swings or they gyrate on raised platforms. In *Ten Cents a Dance* (Fig. 20), the women remain behind the rail. Or, as in *In Fourteenth Street* (Fig. 40) and several other works (Figs. 37, 39), they walk purposefully, controlling their own pictorial space. Their large, full bodies are powerful. The combination of positions and bodies reflects a vision of idealized women who are offered up for public enjoyment but remain inaccessible and unattainable. Truly untouchable, the burlesque "queen" performs on stage, the magnetic center for hundreds of pairs of eyes. These men are held raptly attentive by the one female; they simply stare. In a painting and print such as *Star Burlesk* (Fig. 82), Marsh enhances the position. The stripper is enormous in relation to the audience, and the lighting from below makes her even more imposing.

Marsh's men are frequently behind or beneath the women, watching. On the Bowery, the men are listless; they stand or sit with their hands in their pockets, unable to use them meaningfully. They lie on the ground; they lounge, loaf, wait, or watch. Sometimes these men (and, like the women, they often appear to be the same man) are literally crippled—missing limbs or on crutches.

Marsh's art is characterized not just by a separation but by a contrast of men and women: in the extreme, a contrast of active, striding women and crippled, drunken bums. In the nocturnal scene at the Bowery of *Tattoo—Shave—Haircut* (Fig. 41), a young woman stares out from behind the idle bums, one of whom is on crutches at the front. In *In Fourteenth Street* (Fig. 40), the young woman under the ladder strides to the right, while immediately in front of her a man on crutches walks the other way. In two prints of the *Dance Marathon* (Figs. 8, 52), Marsh focuses on a couple in which the man is worn-out, asleep, and carried around the dance floor by the still-awake woman. In his early linocut *The Garden of Eden*, it is Adam who cringes in the back while Eve remains erect.[56] Even in his *New Yorker* jokes, Marsh implies the weakness of men vis-à-vis women. In one cartoon, a woman takes her wimpy boyfriend to the barrel of love and buys the tickets herself (Fig. 53). In another cartoon, one bum

resignedly pulls the other bum away from a poster of a burlesque dancer, suggesting the ultimate frustration of ever having her (Fig. 85).

Women constantly walk through Marsh's art. He even found them where they did not belong—on the Bowery, for example, in *Tattoo—Shave—Haircut* (Fig. 92). A woman, for him, he once said, "is always a stimulus to paint."[57] Nowhere is this image of woman—ideal, remote, aloof, yet buxom and alluring—more clear than in his recurrent theme, the woman on the merry-go-round horse.[58] From a vehemently drawn small comic-strip character (Fig. 46) she becomes a full-bodied young woman in a 1930 etching, seated sidesaddle on her horse (Fig. 45). In front of her another woman is leered at by the gentleman behind. In a later drawing, her head is tilted upward, as if in an ecstatic vision (Fig. 47). In another drawing (Fig. 48), the frenetic lines enhance the sense of a Baroque vision. By 1943, in an engraving (Fig. 49), the image has become stark and more abstract: there is no background detail; the horse and its rider are divorced from any setting in life. The lady rides astride now, rather than sidesaddle. Her breasts are tense and rigidly erect; she barely needs to steady herself to the post. In this image, the man is no longer present, yet he is implicit: Marsh's ladies always presume an audience.

Marsh's notion of sexuality, in other words, centers on exhibitionism, and its corollary, voyeurism. His world is filled with display: movies, burlesque, beach are all forms of public exhibition. Men and women are spectators and performers within a heavily sexualized world. And Marsh was clearly fascinated by both aspects of that world—almost always presenting its two sides in the same image. Most often the women are the performers and the men their worshipful spectators or customers. But sometimes, as with the musclemen at the beach, the men themselves become the performers. It was the relationship that was important: performing and watching. Within the construct of Marsh's world, seeing and being seen become the pictorial references for sexuality.[59]

In fact, the joke—or sad irony—in his art is that men are sometimes unable to see or to rouse themselves to the beautiful women who walk by. He tells this same joke over and over again. He began telling it in the early 1920s in the cartoon "Subway Sunbeams," captioned "Concentration" (Fig. 54). In it the men reading newspapers are oblivious to the lovely flapper straphanging over them. Over twenty years later, in *Eyes Examined* (Fig. 55), the striding young woman, a vision of loveliness, hair flowing, is unseen by the two men standing and sitting beside her. The eyeglass sign overhead pops out at the spectator; these men ought to have their eyes examined. In *Eyes Tested*, the same subject appears, but the man behind the woman is on crutches and missing a limb, while the man next to her is drowsing in a doorway. Crippled or sleeping, neither man is a physical match for the image of female perfection.

In Marsh's 1930 painting *Why Not Use the "L"?* (Fig. 108), the same contrast is subtly present. The slum-

Fig. 46. Woman on a merry-go-round horse, c. 1927–30. Charcoal pencil on paper, 5¼ × 7⅞ inches. Whitney Museum of American Art, New York; Bequest of Felicia Meyer Marsh T78.1.509.

Fig. 47. Woman on a merry-go-round horse, c. 1938. Pencil on paper, 8¼ × 6 inches. Whitney Museum of American Art, New York; Bequest of Felicia Meyer Marsh T78.1.78.

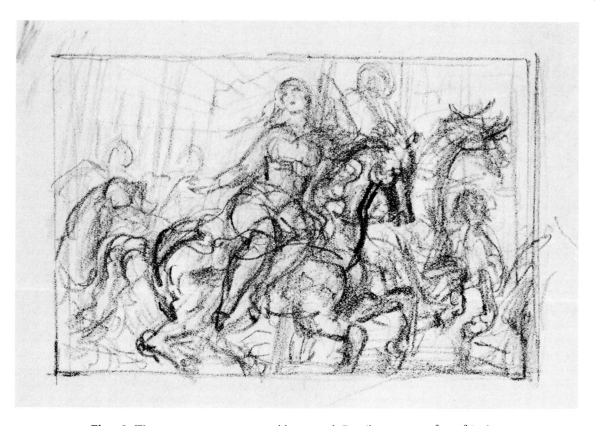

Fig. 48. Woman on a merry-go-round horse, n.d. Pencil on paper, 10¾ × 8⅝ inches. Whitney Museum of American Art, New York; Bequest of Felicia Meyer Marsh T78.1.152.

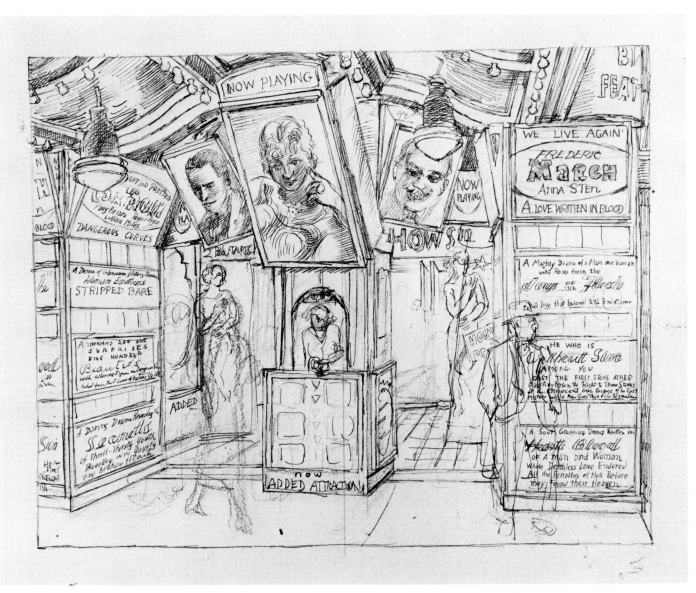

Fig. 69. Study for *Twenty Cent Movie*, 1936. Ink and pencil on paper, $9\frac{1}{2} \times 12\frac{3}{8}$ inches. Whitney Museum of American Art, New York; Gift of Edith and Lloyd Goodrich 73.1.

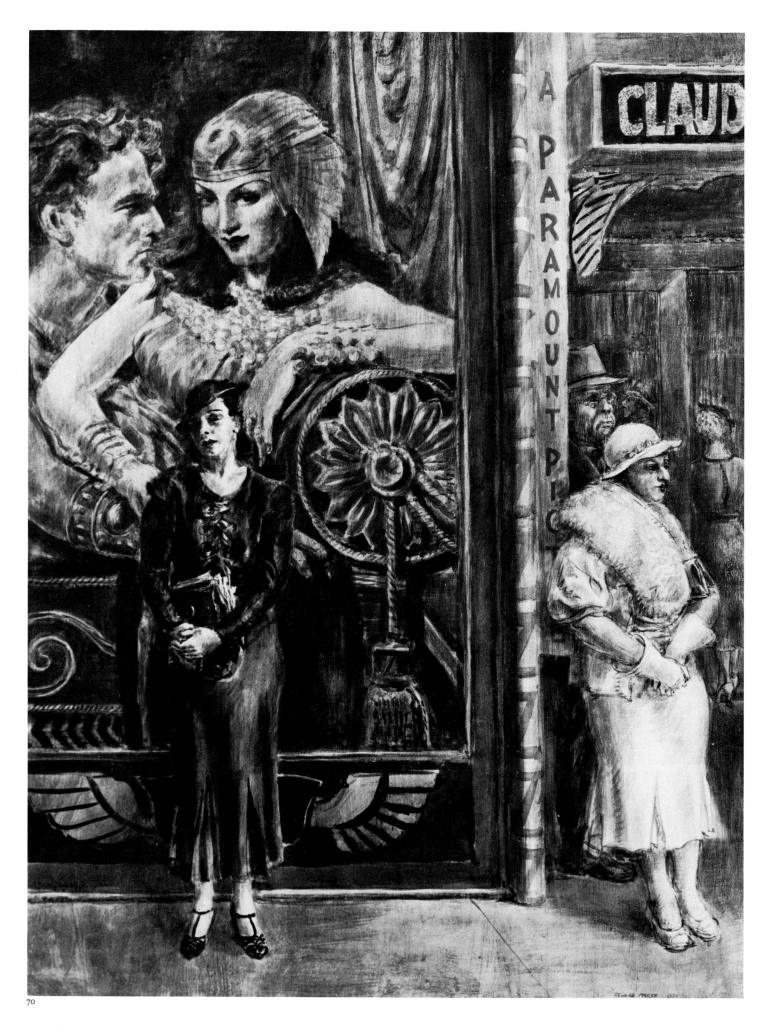

70

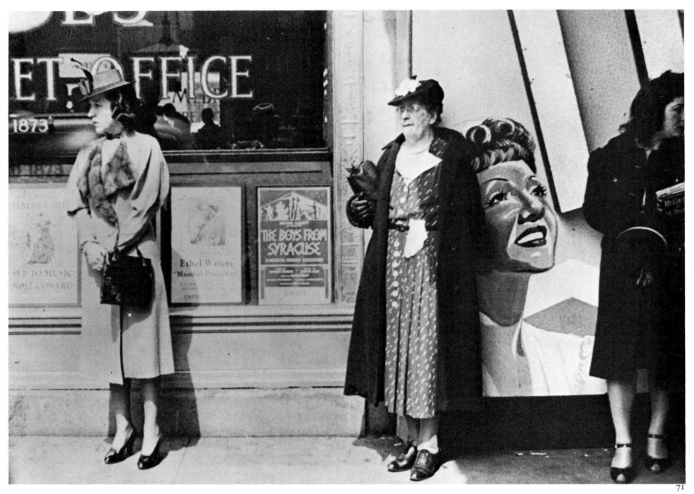

Fig. 70. *Paramount Pictures*, 1934. Tempera on panel, 36 × 30 inches. Collection of Marjorie and Charles Benton. (In color on inside front cover)
Fig. 71. Broadway and Fourteenth Street, c. 1938–39. Photograph. Print Archives, Museum of the City of New York; Bequest of Felicia Meyer Marsh.

FOURTEENTH
STREET

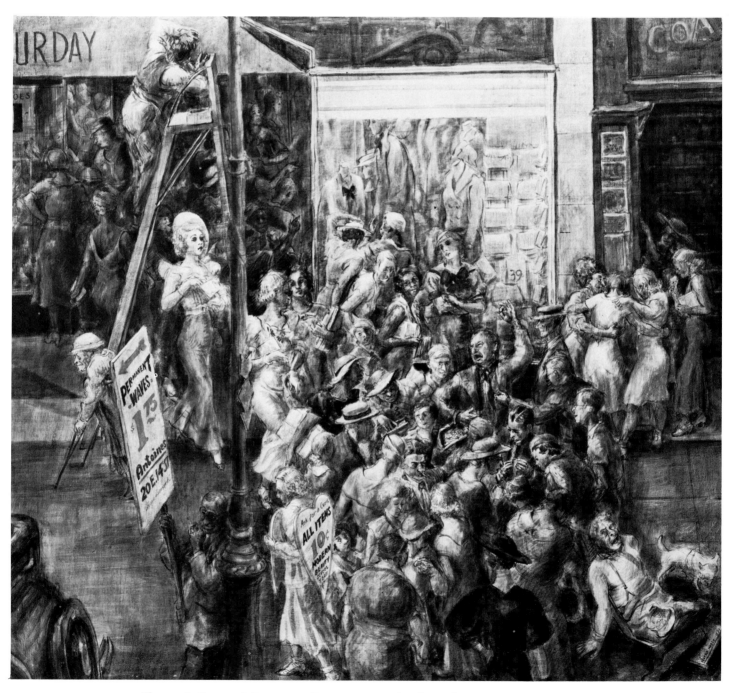

Fig. 72. *In Fourteenth Street*, 1934. Tempera on panel, $35\frac{7}{8} \times 39\frac{3}{4}$ inches. The Museum of
Modern Art, New York; Gift of Felicia Meyer Marsh.

Fig. 73. Photograph album, c. 1933. Print Archives, Museum of the City of New York; Bequest of Felicia Meyer Marsh.

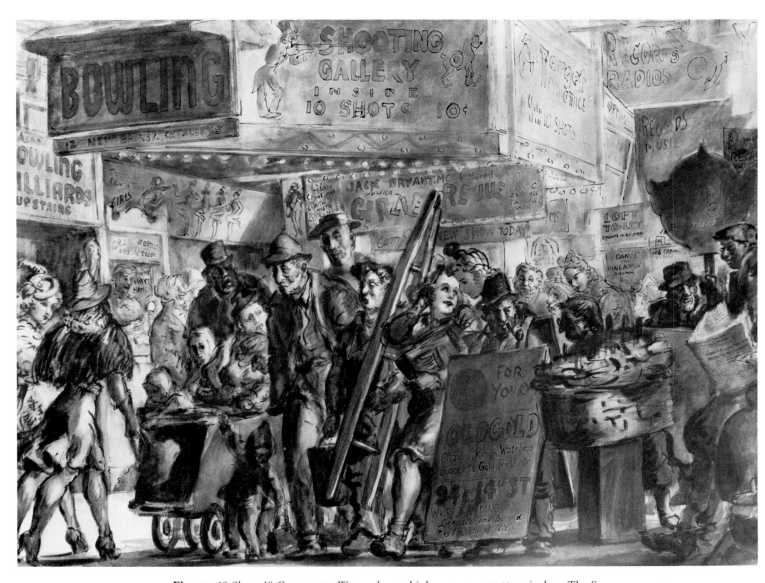

Fig. 74. *10 Shots, 10 Cents*, 1939. Watercolor and ink on paper, 27 × 40 inches. The St. Louis Art Museum; The Eliza McMillan Fund.

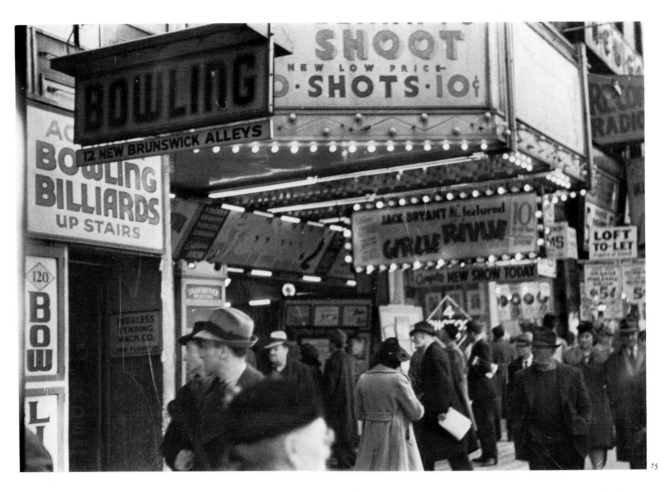

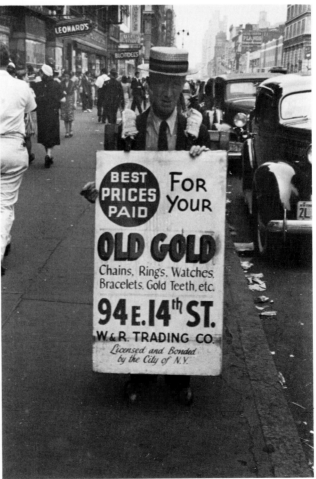

Figs. 75, 76. Fourteenth Street, 1939. Photographs. Print Archives, Museum of the City of New York; Bequest of Felicia Meyer Marsh.

BURLESQUE
AND DANCE HALLS

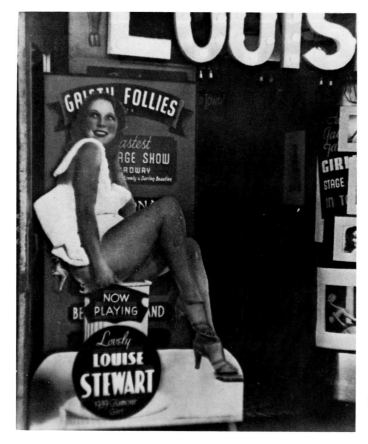

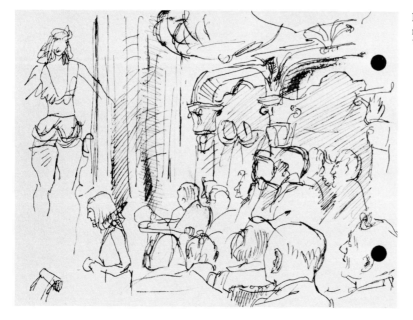

Fig. 77. Broadway, 1939. Photograph. Print Archives, Museum of the City of New York; Bequest of Felicia Meyer Marsh.

Fig. 78. Burlesque theater, c. 1929. Sketchbook no. 132. The Metropolitan Museum of Art, New York; Bequest of Felicia Meyer Marsh.

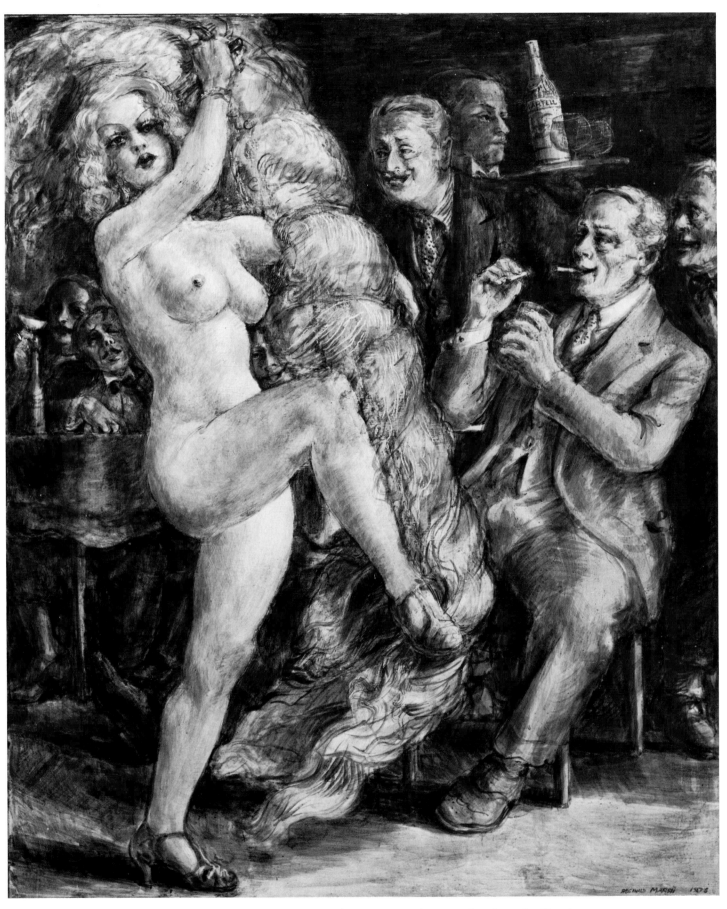

Fig. 79. *Down at Jimmy Kelly's*, 1936. Tempera on panel, 36 × 30¼ inches. The Chrysler
Museum, Norfolk, Virginia; Gift of Walter P. Chrysler, Jr.

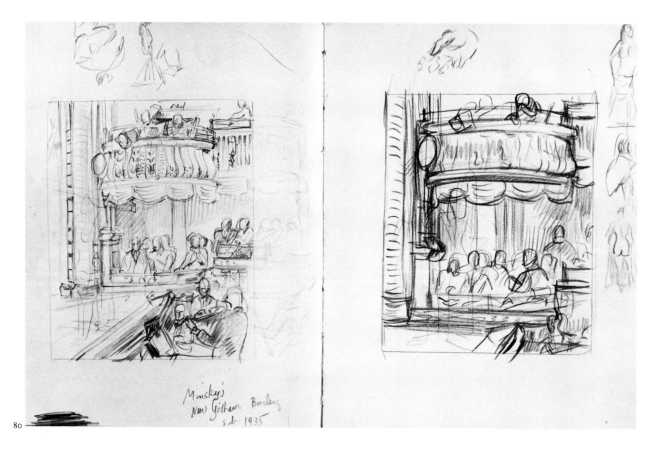

80

81

Fig. 80. Studies for *Striptease at New Gotham*, 1935. Sketchbook no. 126. Whitney Museum of American Art, New York; Bequest of Felicia Meyer Marsh T78.1.858.

Fig. 81. Burlesque theater (Star Burlesk), 1933. Pencil on paper, $12\frac{5}{8} \times 9\frac{1}{4}$ inches. Whitney Museum of American Art, New York; Bequest of Felicia Meyer Marsh T78.1.1066.

Fig. 82. *Star Burlesk*, 1933 (restruck 1969). Etching, $11\frac{3}{4} \times 8\frac{3}{4}$ inches. Whitney Museum of American Art, New York; Original plate donated by William Benton 69.97l.

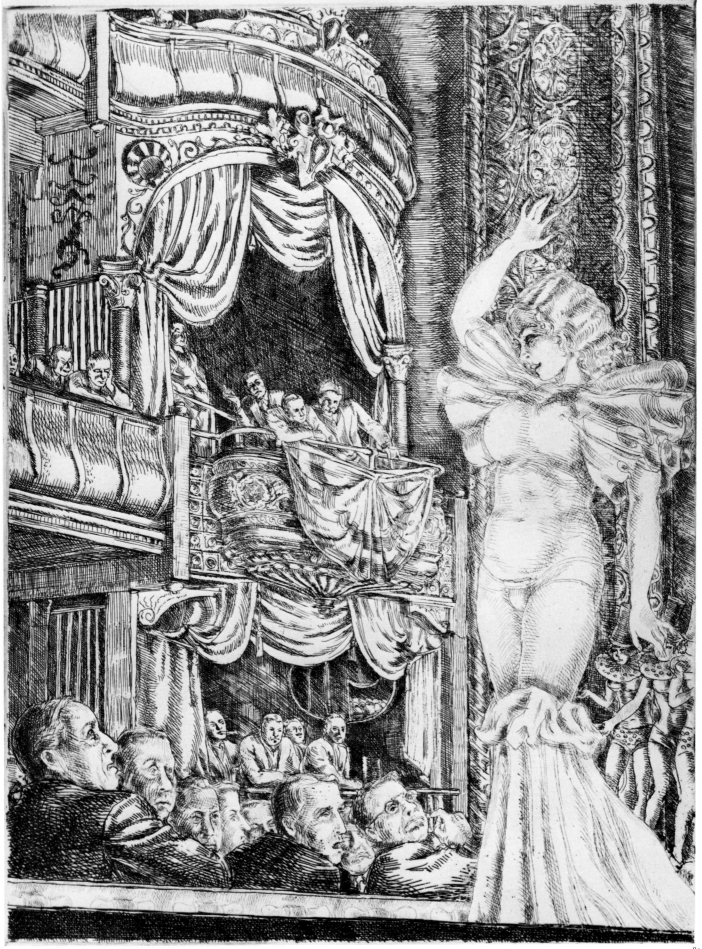

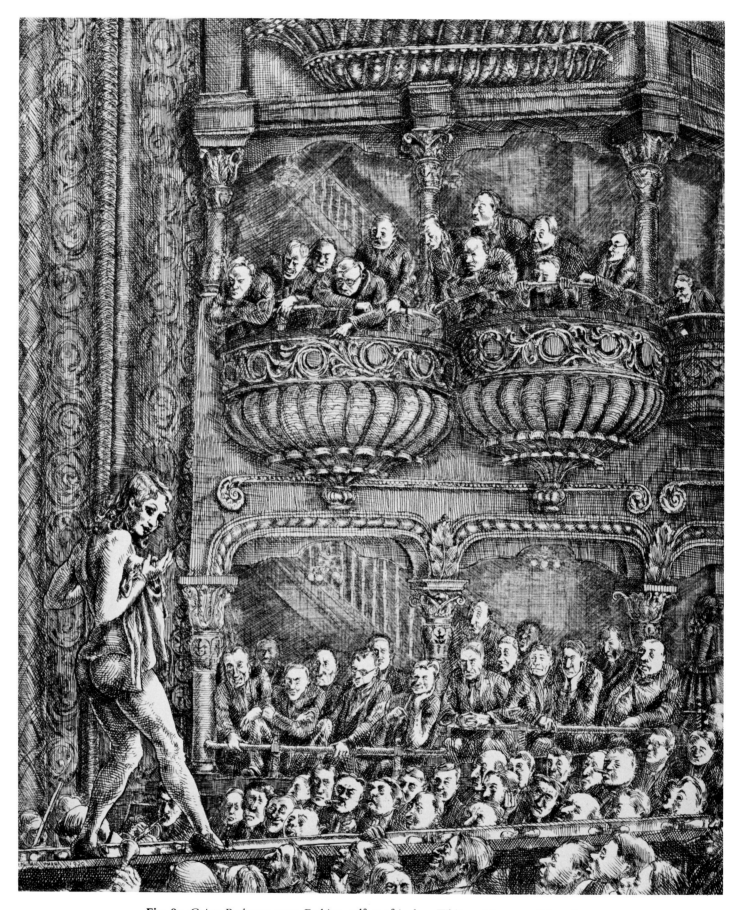

Fig. 83. *Gaiety Burlesque*, 1930. Etching, 11¹³⁄₁₆ × 9¾ inches. Whitney Museum of American Art, New York; Purchase 31.777.

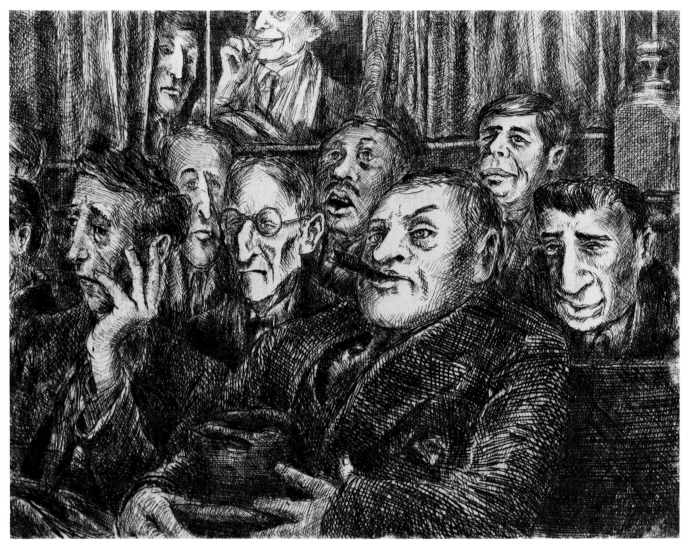

Fig. 84. *Audience Burlesk*, 1929. Etching, 6 × 8 inches. The William Benton Museum of Art, University of Connecticut, Storrs.

Fig. 85. "Come on Al, that's not getting you anywhere," from *The New Yorker*, March 16, 1929. Clipping in scrapbook no. 6. Reginald Marsh Papers, Archives of American Art, Smithsonian Institution, Washington, D.C.

THE BOWERY

Fig. 86. Streets near the Bowery, 1931. Sketchbook no. 160. The Metropolitan Museum of Art, New York; Bequest of Felicia Meyer Marsh.
Fig. 87. Sketches for *Chatham Square*, 1931. Sketchbook no. 160. The Metropolitan Museum of Art, New York; Bequest of Felicia Meyer Marsh.

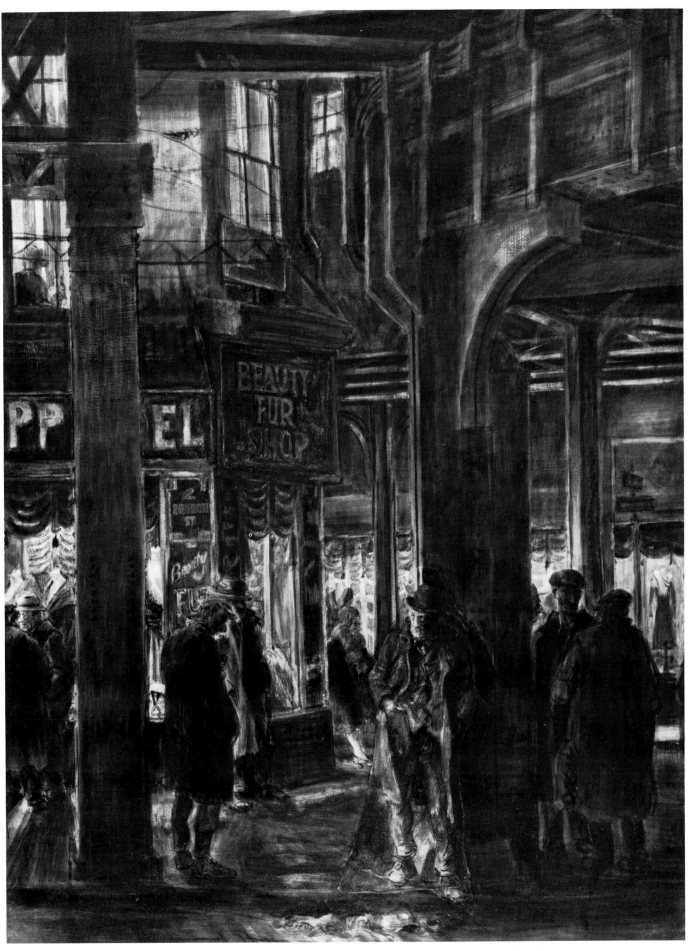

Fig. 88. *Chatham Square*, 1931. Tempera on panel, 47½ × 35¼ inches. Archer M. Huntington Art Gallery, University of Texas, Austin; The James and Mari Michener Collection.

Figs. 89–91. Sketches for *Tattoo and Haircut*, 1932 (also used for *Tattoo—Shave—Haircut*, 1932). Sketchbook no. 59. The Metropolitan Museum of Art, New York; Bequest of Felicia Meyer Marsh.

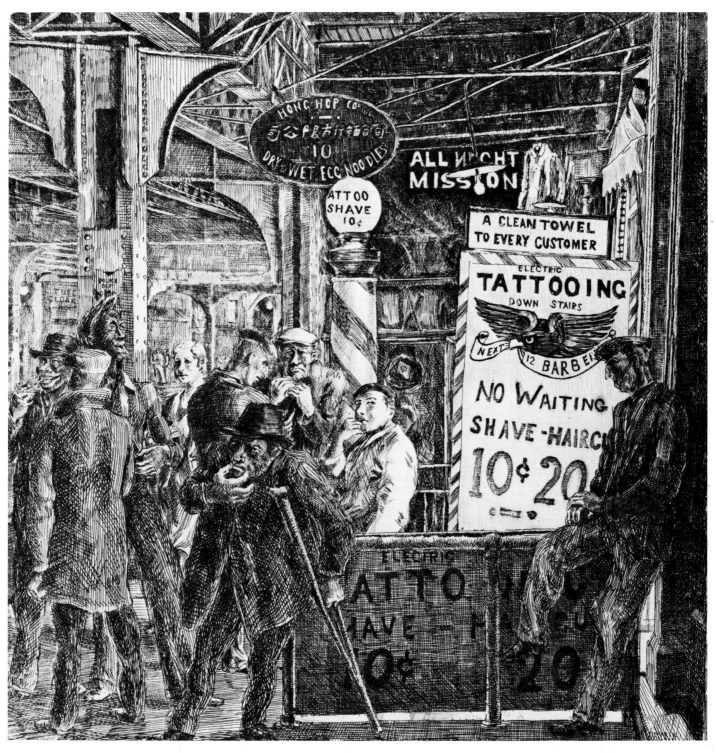

Fig. 92. *Tattoo—Shave—Haircut*, 1932 (restruck 1969). Etching, $9\frac{7}{8} \times 9\frac{5}{8}$ inches. Whitney Museum of American Art, New York; Original plate donated by William Benton 69.97k.

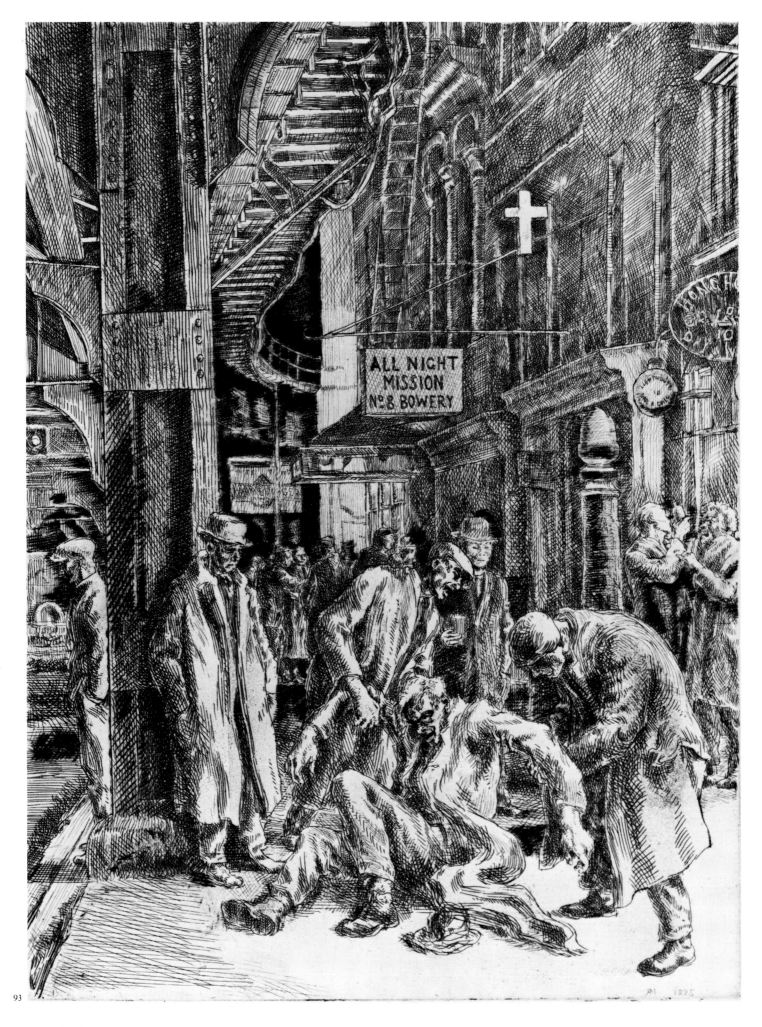

93

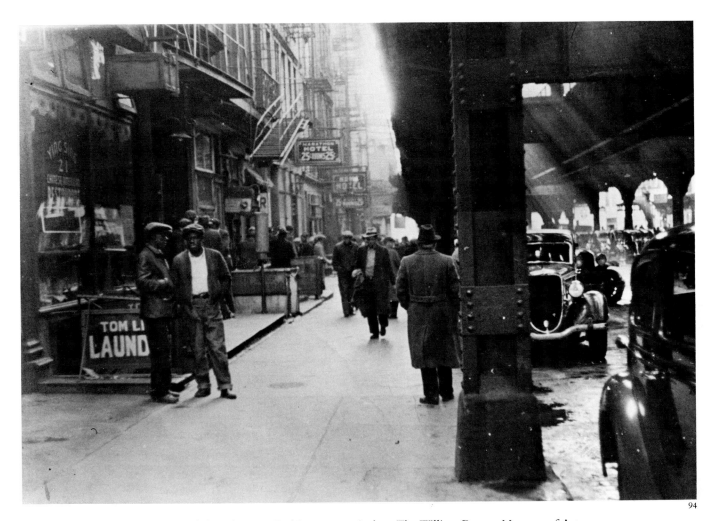

Fig. 93. *Smokehounds*, 1934. Etching, 12 × 9 inches. The William Benton Museum of Art, University of Connecticut, Storrs.
Fig. 94. The Bowery, 1938. Photograph. Print Archives, Museum of the City of New York; Bequest of Felicia Meyer Marsh.

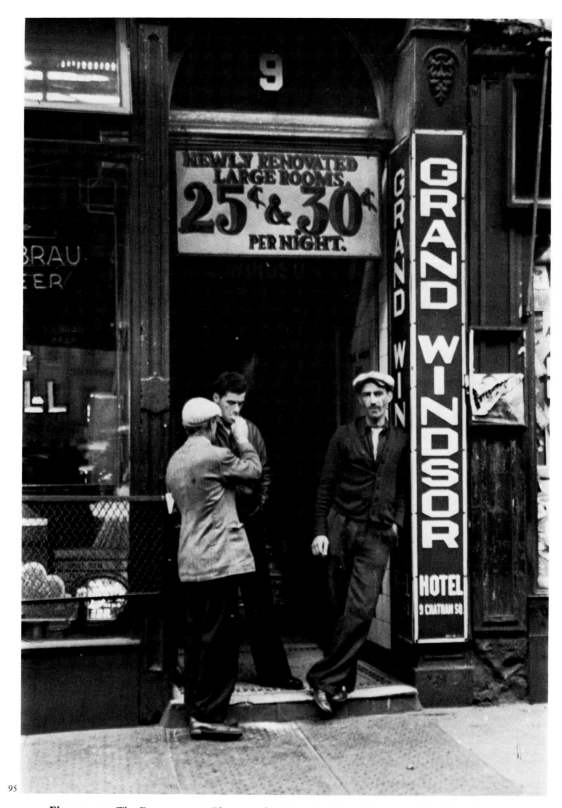

95

Figs. 95–97. The Bowery, 1938. Photographs. Print Archives, Museum of the City of New York; Bequest of Felicia Meyer Marsh.

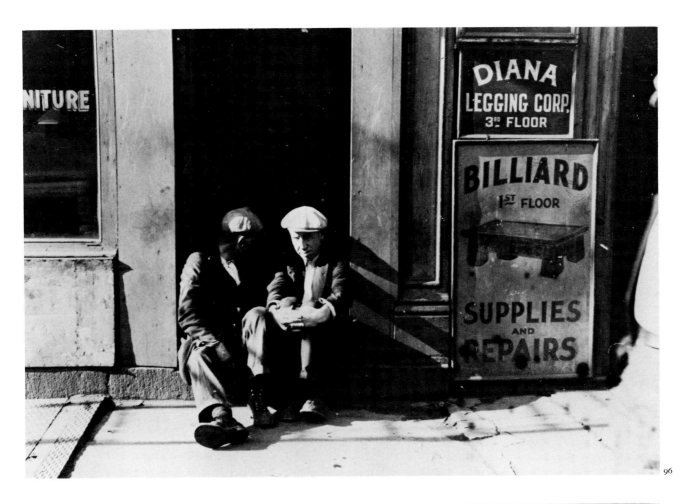

96

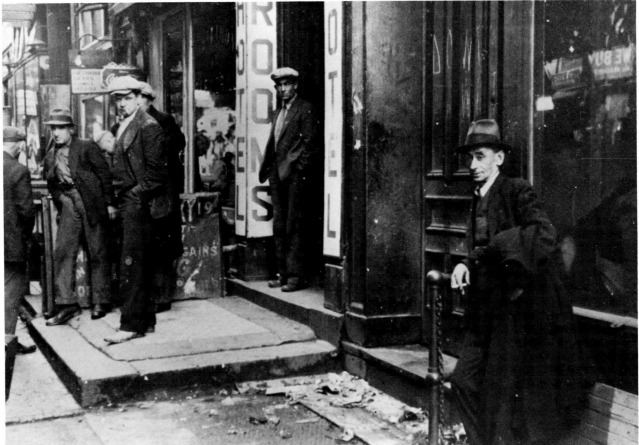

97

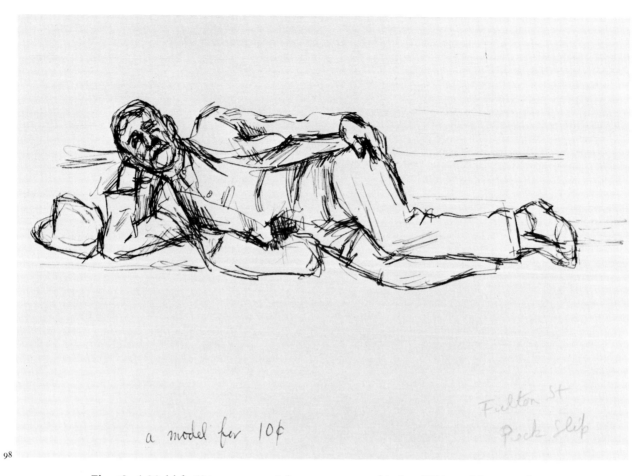

a model for 10¢

Fulton St
Peck Slip

98

Fig. 98. *A Model for 10¢*, c. 1927–30. Ink on paper, 9 × 11½ inches. Whitney Museum of American Art, New York; Bequest of Felicia Meyer Marsh 80.31.102.
Fig. 99. The Bowery, 1938. Photograph. Print Archives, Museum of the City of New York; Bequest of Felicia Meyer Marsh.

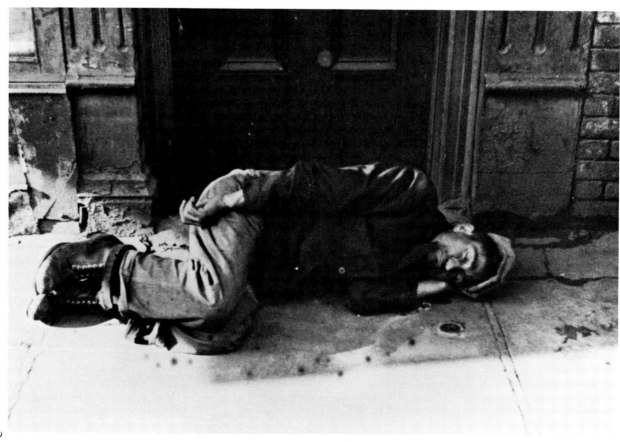

99

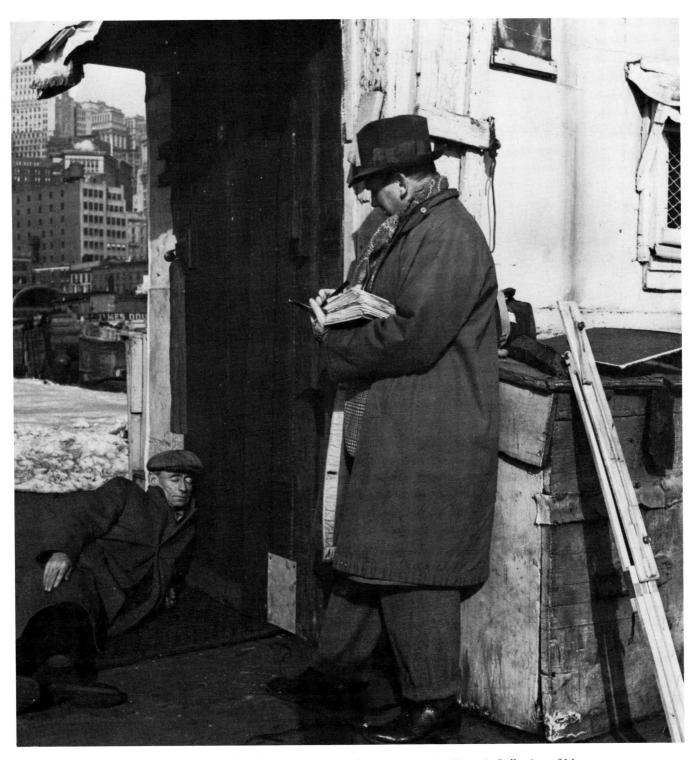

Fig. 100. Marsh sketching Walter Broe on the Bowery, 1930s (see Fig. 97). Collection of Mr. and Mrs. Joel W. Harnett.

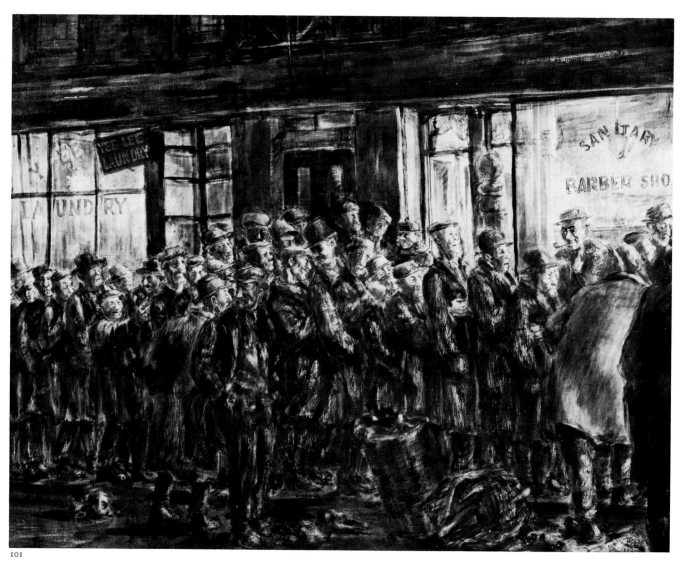

101

Fig. 101. *Holy Name Mission*, 1931. Tempera on panel, $35\frac{1}{2} \times 47\frac{1}{2}$ inches. Collection of International Business Machines Corporation, Armonk, New York.
Fig. 102. Sketches for *Holy Name Mission*, 1931. Sketchbook no. 130. The Metropolitan Museum of Art, New York; Bequest of Felicia Meyer Marsh.

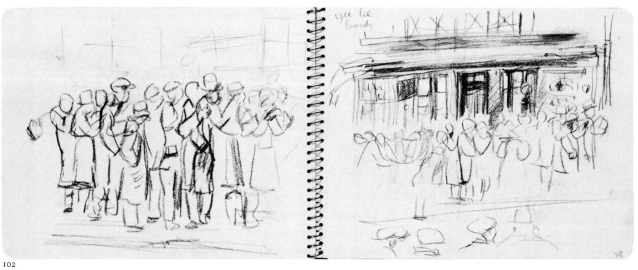

102

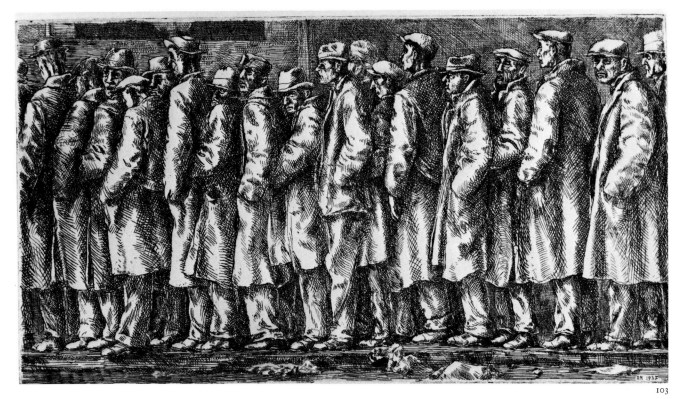

Fig. 103. *Bread Line—No One Has Starved*, 1932 (restruck 1969). Etching, 6¼ × 11⅞ inches. Whitney Museum of American Art, New York; Original plate donated by William Benton 69.97j.
Fig. 104. Sketch for *Bread Line—No One Has Starved*, 1932. Pencil on paper, 8½ × 14. Whitney Museum of American Art, New York; Bequest of Felicia Meyer Marsh 80.31.29.

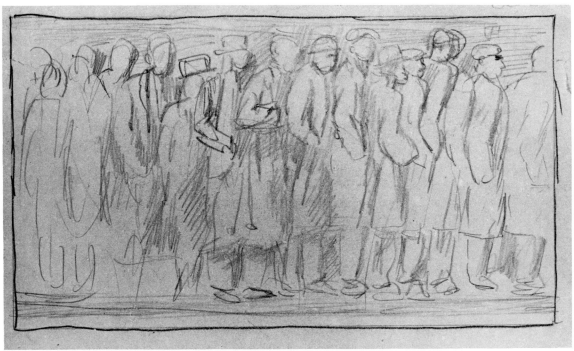

THE SUBWAY

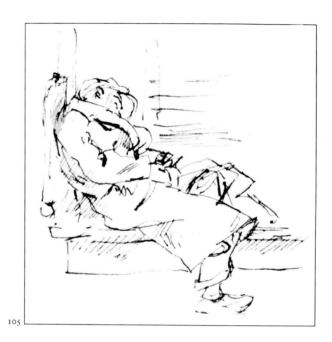

105

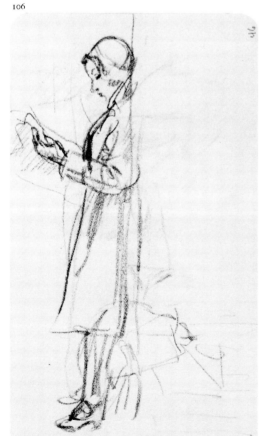

106

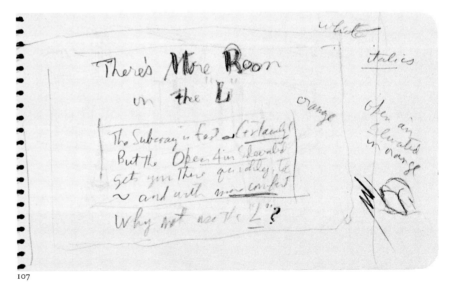

107

Fig. 105. Sketch for *Why Not Use the "L"?*, 1930.
Sketchbook no. 132. The Metropolitan Museum of
Art, New York; Bequest of Felicia Meyer Marsh.
Figs. 106, 107. Sketches for *Why Not Use the "L"?*, 1930.
Sketchbook no. 179. The Metropolitan Museum of Art,
New York; Bequest of Felicia Meyer Marsh.

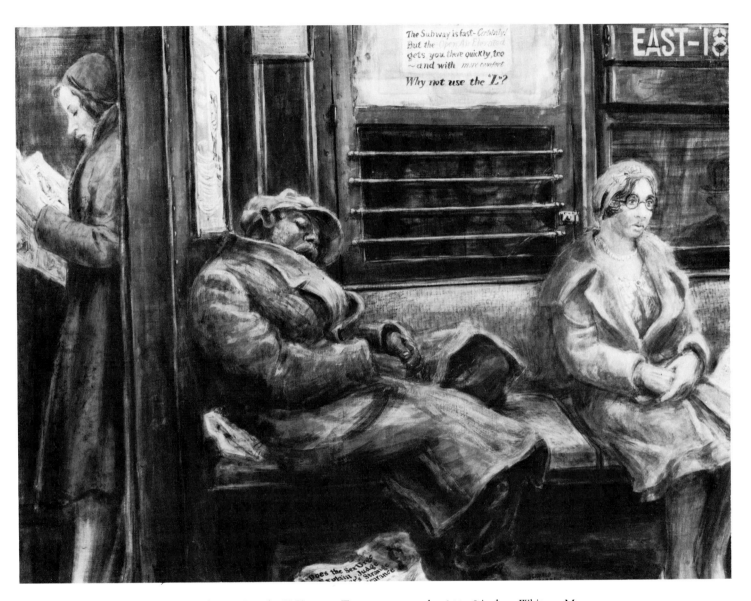

Fig. 108. *Why Not Use the "L"?*, 1930. Tempera on panel, 36 × 48 inches. Whitney Museum of American Art, New York; Purchase 31.293.

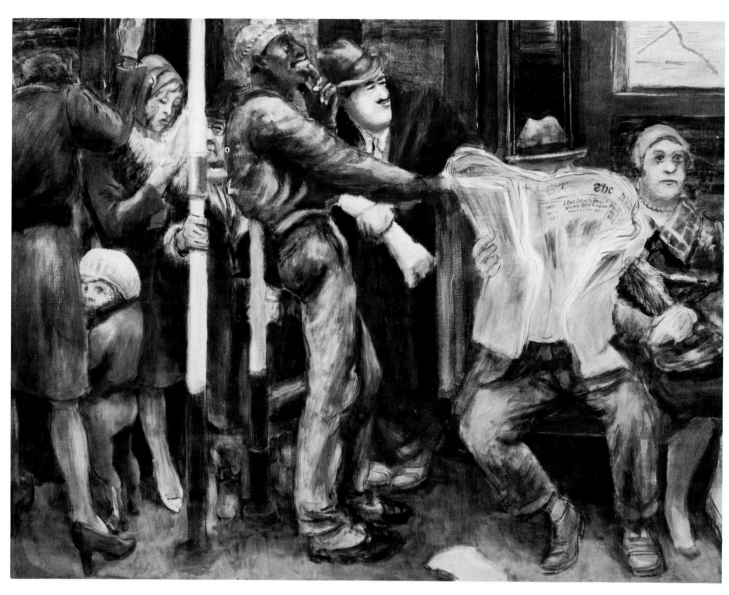

Fig. 109. *People Seated and Standing on Subway*, c. 1928. Oil on canvas, 36 × 48 inches.
Whitney Museum of American Art, New York; Bequest of Felicia Meyer Marsh 80.31.8.

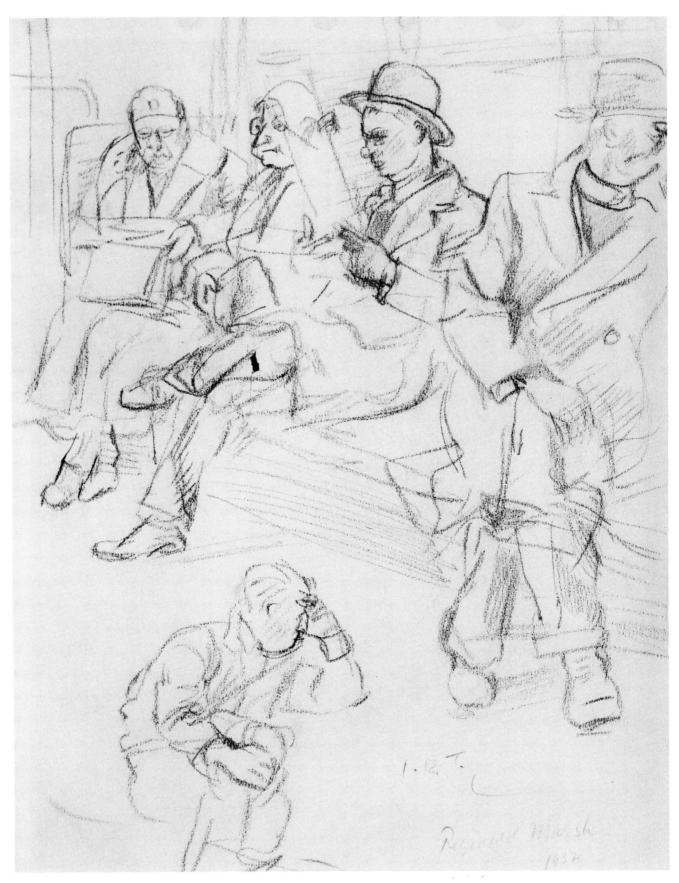

Fig. 110. *I.R.T.*, 1932. Charcoal pencil on paper, 10 × 8 inches. Whitney Museum of American Art, New York; Bequest of Felicia Meyer Marsh T78.1.1021.

Fig. 111 Subway, 1939. Photograph. Print Archives, Museum of the City of New York;
Bequest of Felicia Meyer Marsh.
Fig. 112. People on a subway, c. 1930. Charcoal pencil on paper, $4\frac{1}{2} \times 7\frac{1}{16}$ inches. Whitney
Museum of American Art, New York; Bequest of Felicia Meyer Marsh T78.1.753.

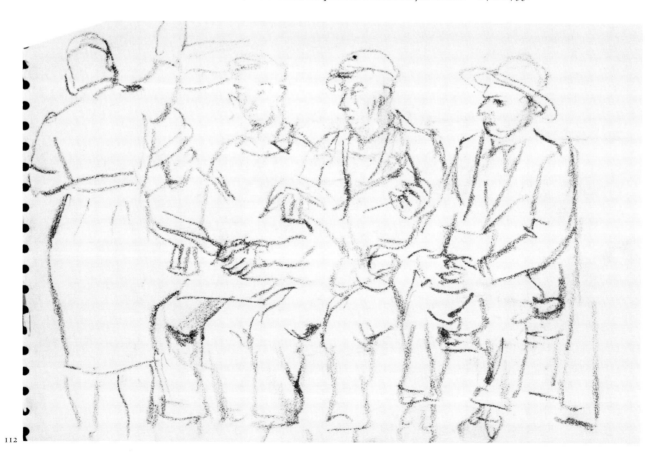

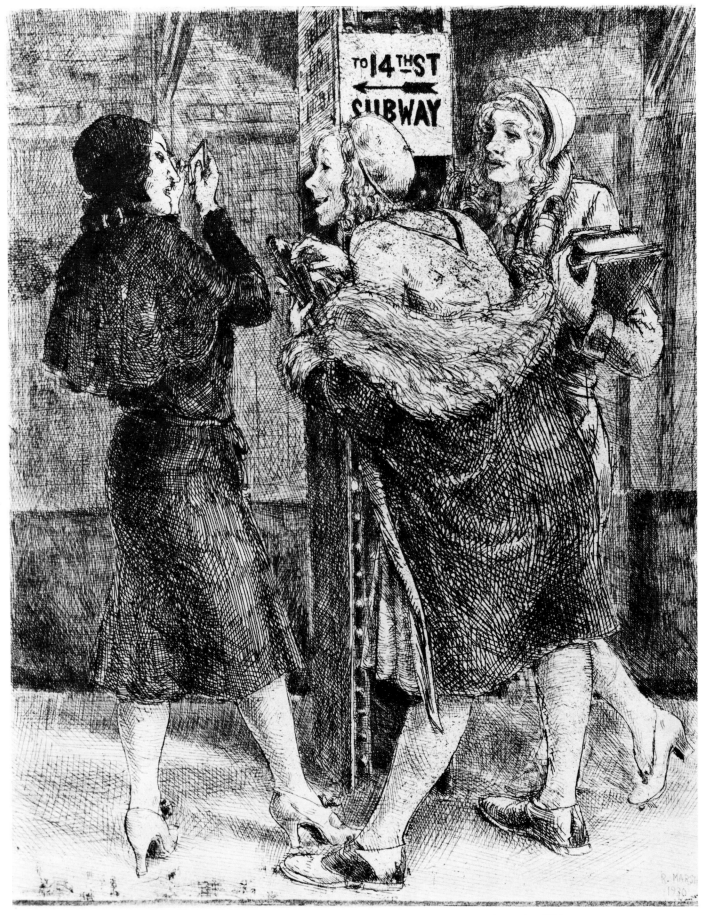

Fig. 113. *Schoolgirls in Subway–Union Square*, 1930. Etching, 10 × 8 inches. The William Benton Museum of Art, University of Connecticut, Storrs.

THE BEACH

Fig. 114. Coney Island, 1938. Photograph. Print Archives, Museum of the City of New York; Bequest of Felicia Meyer Marsh.

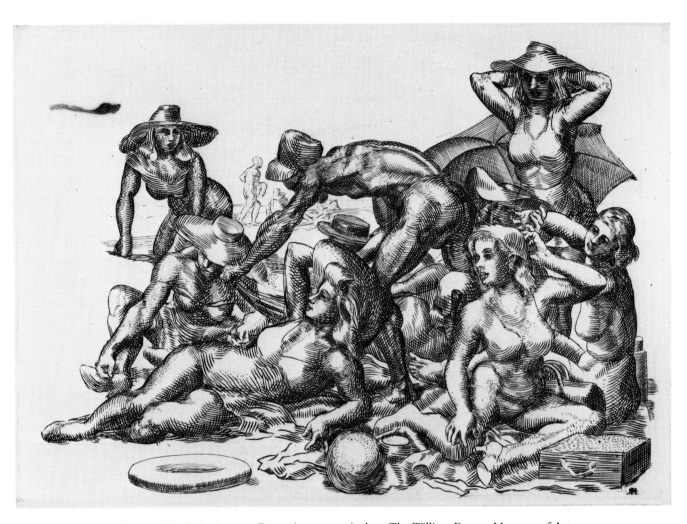

Fig. 115. *Beach Picnic*, 1939. Engraving, 5 × 7 inches. The William Benton Museum of Art, University of Connecticut, Storrs.

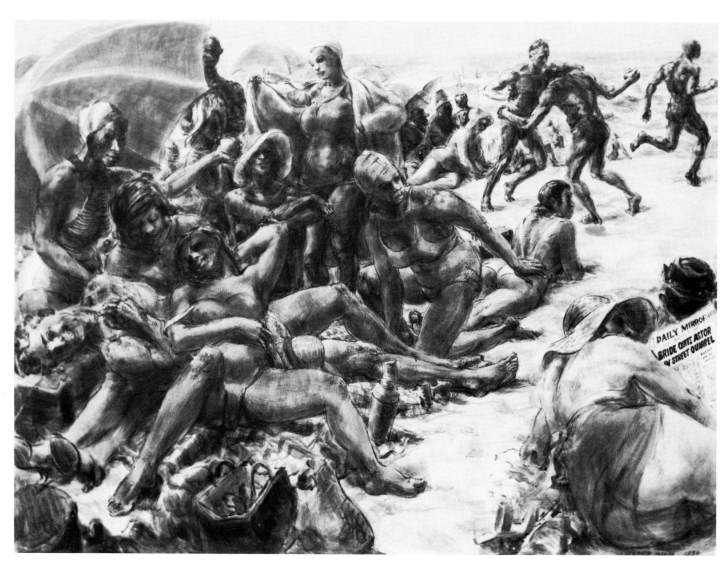

Fig. 116. *Negroes on Rockaway Beach,* 1934. Tempera on panel, 30 × 40 inches. Whitney Museum of American Art, New York; Gift of Mr. and Mrs. Albert Hackett 61.2.

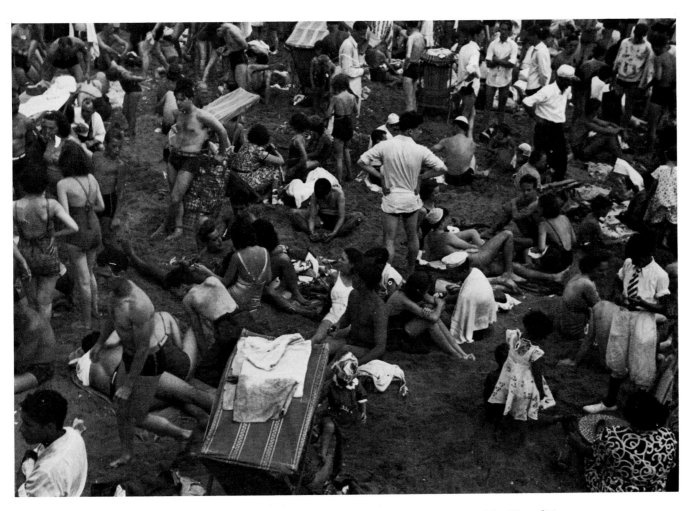

Fig. 117. Coney Island, 1938. Photograph. Print Archives, Museum of the City of New York; Bequest of Felicia Meyer Marsh.

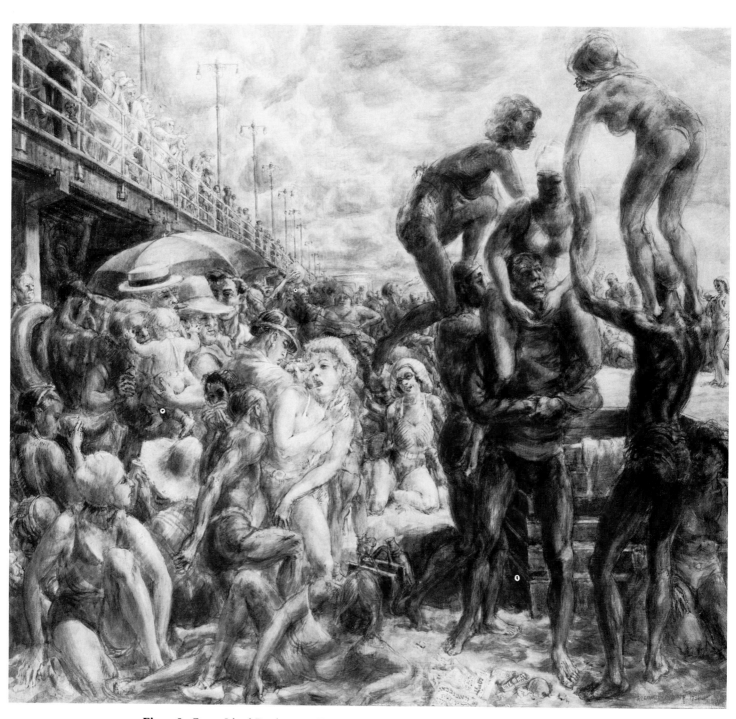

Fig. 118. *Coney Island Beach*, 1934. Tempera on panel, 36 × 40 inches. Yale University Art Gallery, New Haven, Connecticut; Gift of Felicia Meyer Marsh.

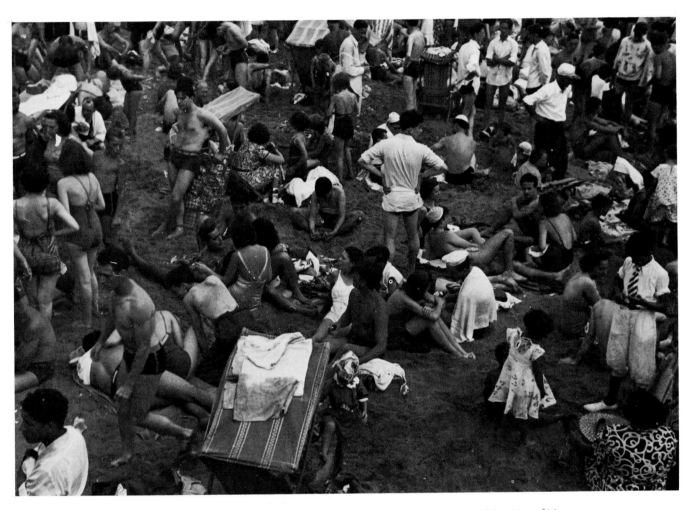

Fig. 117. Coney Island, 1938. Photograph. Print Archives, Museum of the City of New York; Bequest of Felicia Meyer Marsh.

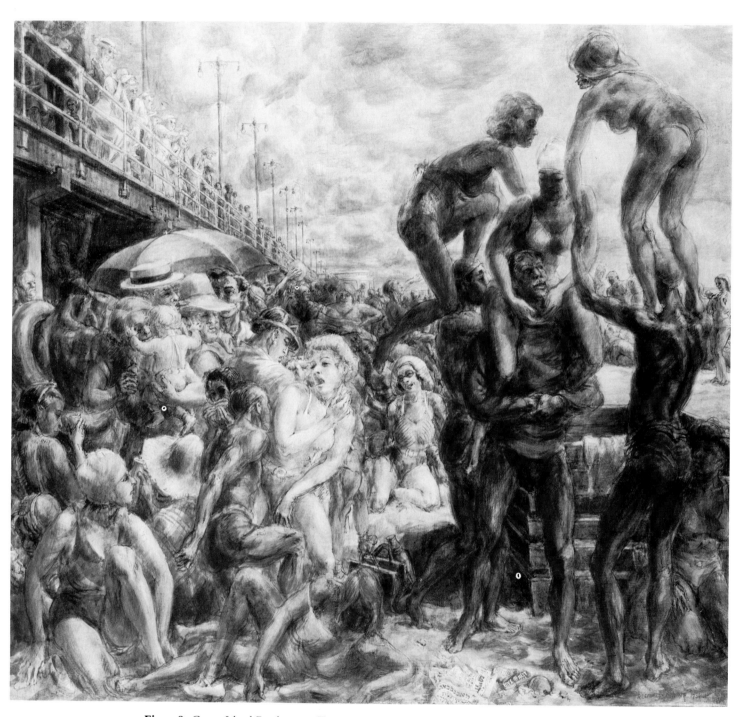

Fig. 118. *Coney Island Beach*, 1934. Tempera on panel, 36 × 40 inches. Yale University Art Gallery, New Haven, Connecticut; Gift of Felicia Meyer Marsh.

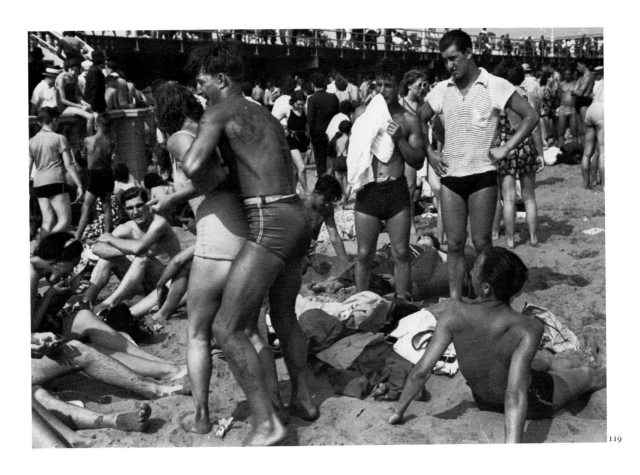

Fig. 119. Coney Island, 1938. Photograph. Print Archives, Museum of the City of New York; Bequest of Felicia Meyer Marsh.
Fig. 120. Coney Island, 1939. Photograph. Print Archives, Museum of the City of New York; Bequest of Felicia Meyer Marsh.

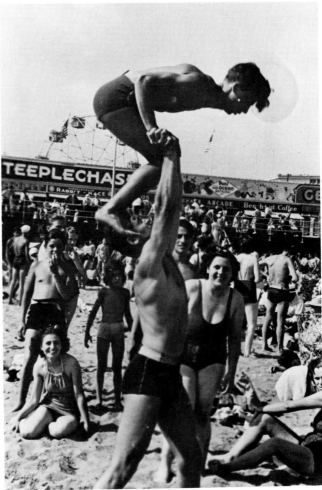

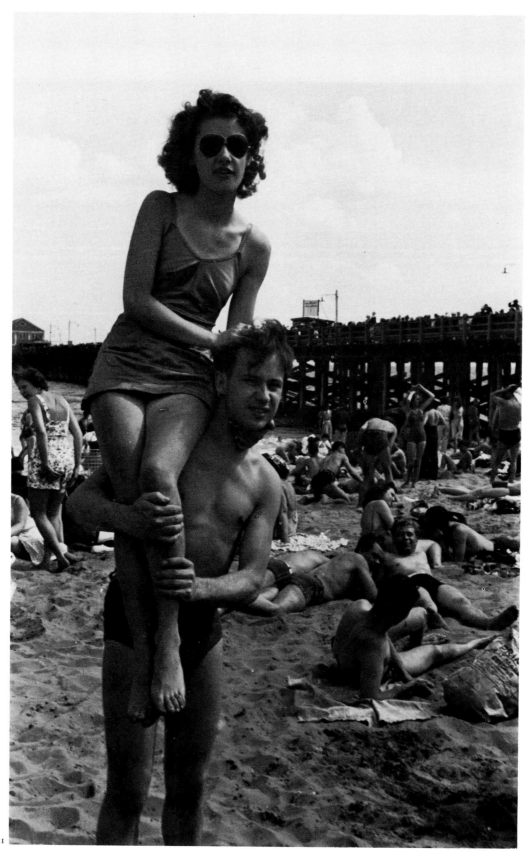

121

Fig. 121. Coney Island, 1940. Photograph. Print Archives, Museum of the City of New York; Bequest of Felicia Meyer Marsh.
Fig. 122. *Pickaback*, 1939 (restruck 1969). Engraving, $9\frac{7}{8} \times 4\frac{7}{8}$ inches. Whitney Museum of American Art, New York; Original plate donated by William Benton 69.97v.

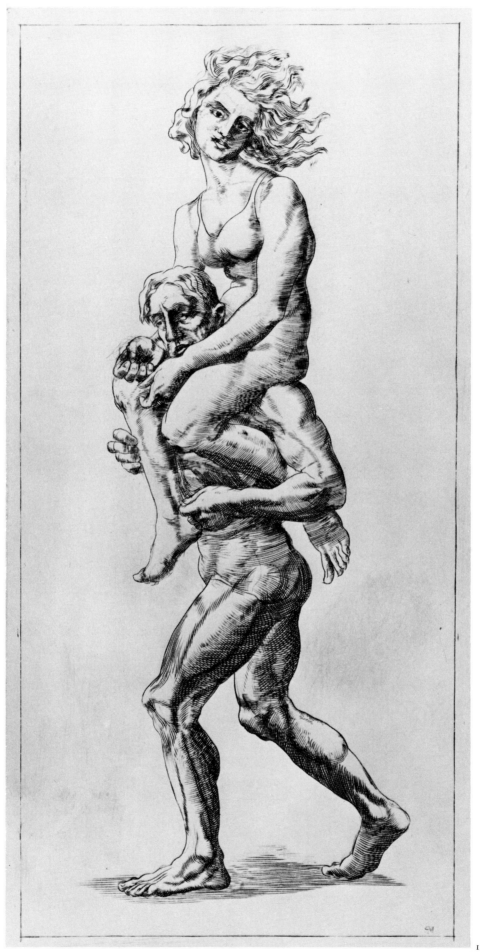

122

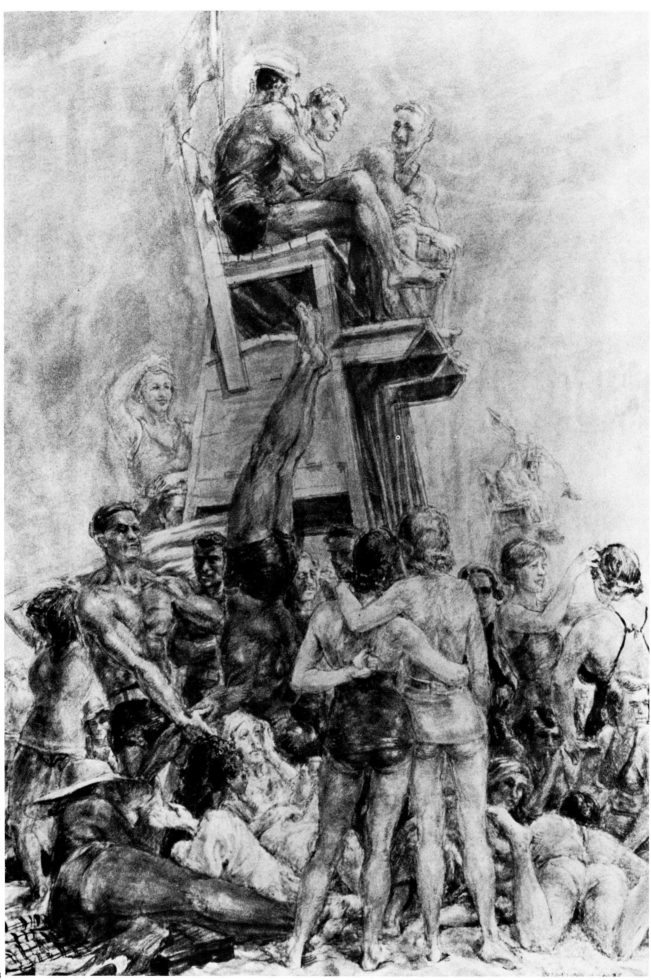

123

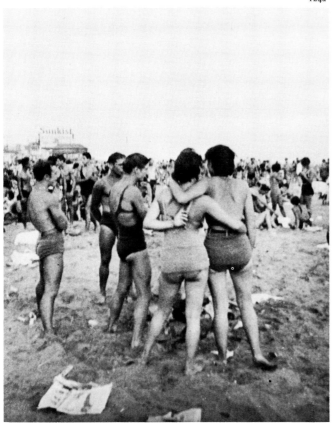

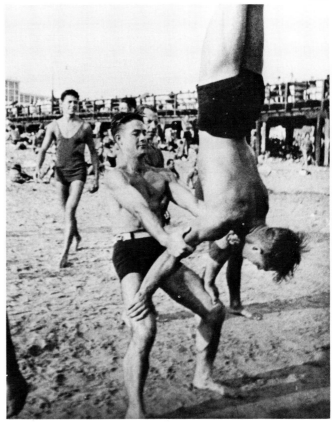

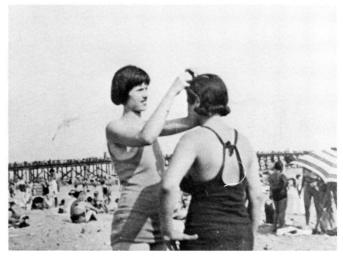

Fig. 123. *Lifeguards*, 1933. Tempera on panel, $35\frac{1}{2}$ × $23\frac{5}{8}$ inches. Georgia Museum of Art, University of Georgia, Athens; Purchased from the United States Department of State, War Assets Administration. (In color on inside back cover)

Fig. 124. Coney Island and Jones Beach, 1933. Snapshots (used for *Lifeguards*, 1933). Print Archives, Museum of the City of New York; Bequest of Felicia Meyer Marsh.

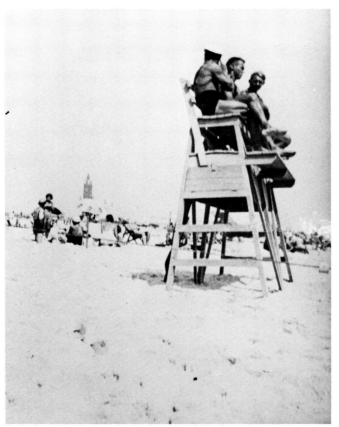

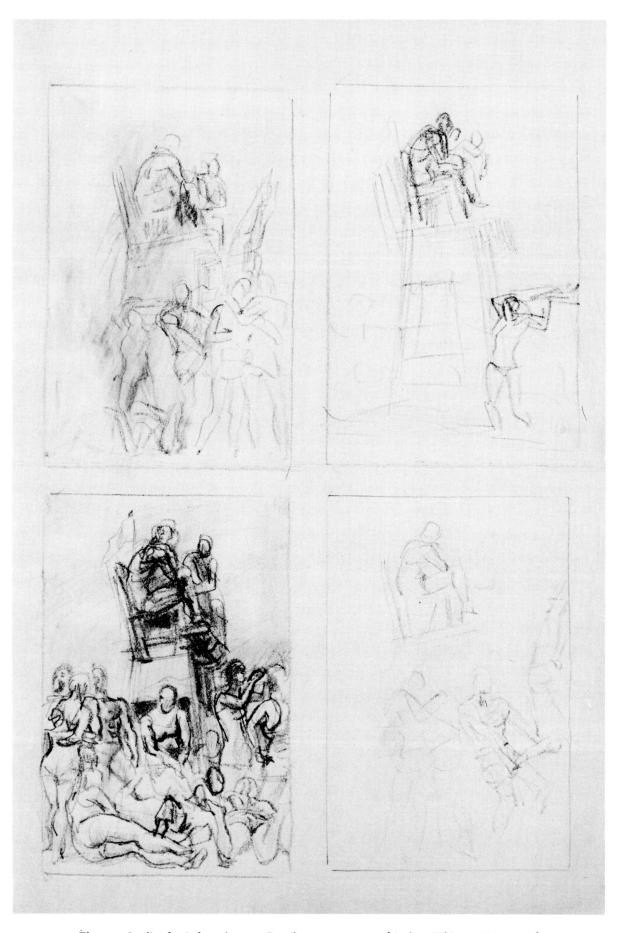

Fig. 125. Studies for *Lifeguards*, 1933. Pencil on paper, 15 × 10½ inches. Whitney Museum of American Art, New York; Bequest of Felicia Meyer Marsh T78.1.1103.

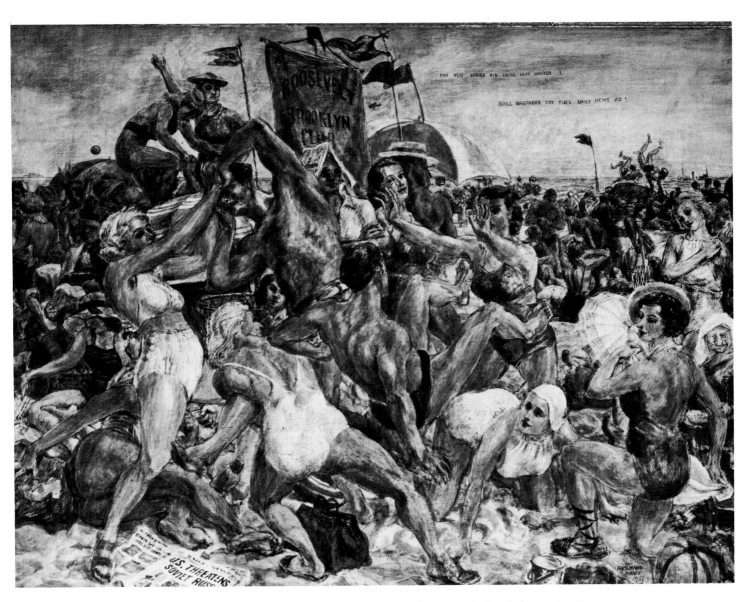

Fig. 126. *Coney Island Beach*, 1935. Tempera on panel, 30 × 40 inches. Private collection.

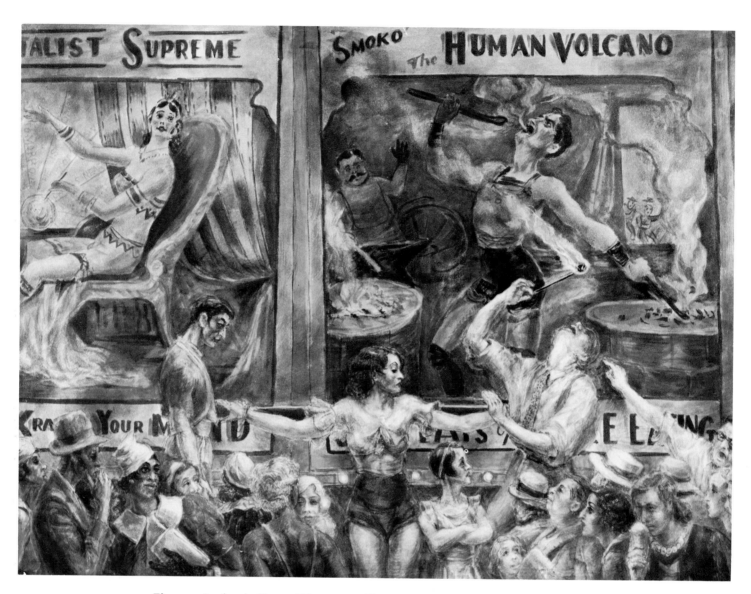

Fig. 127. *Smoko, the Human Volcano*, 1933. Tempera on panel, 36 × 48 inches. Thyssen-Bornemisza Collection, Lugano, Switzerland.

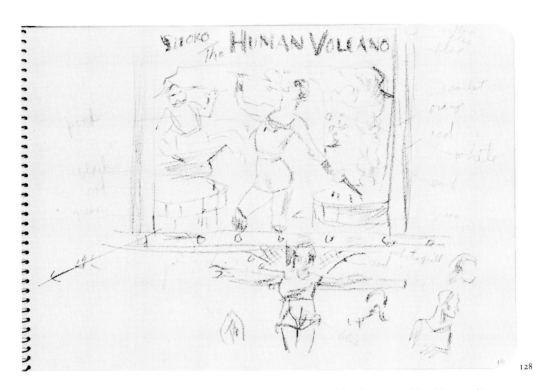

Fig. **128.** Sketch for *Smoko, the Human Volcano*, 1933. Sketchbook no. 83. The Metropolitan Museum of Art, New York; Bequest of Felicia Meyer Marsh.
Fig. **129.** Sideshow at Coney Island, 1933. Snapshots (used for *Smoko, the Human Volcano*, 1933). Print Archives, Museum of the City of New York; Bequest of Felicia Meyer Marsh.

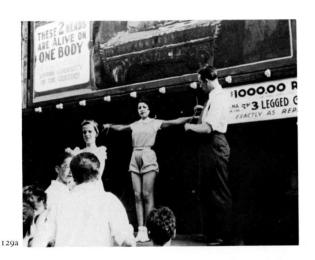

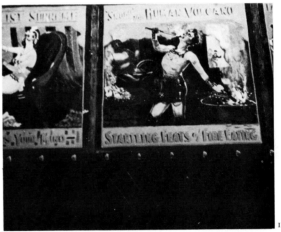

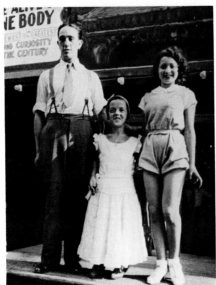

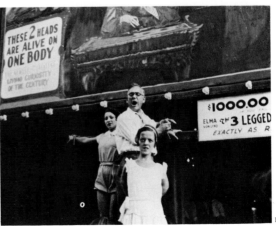

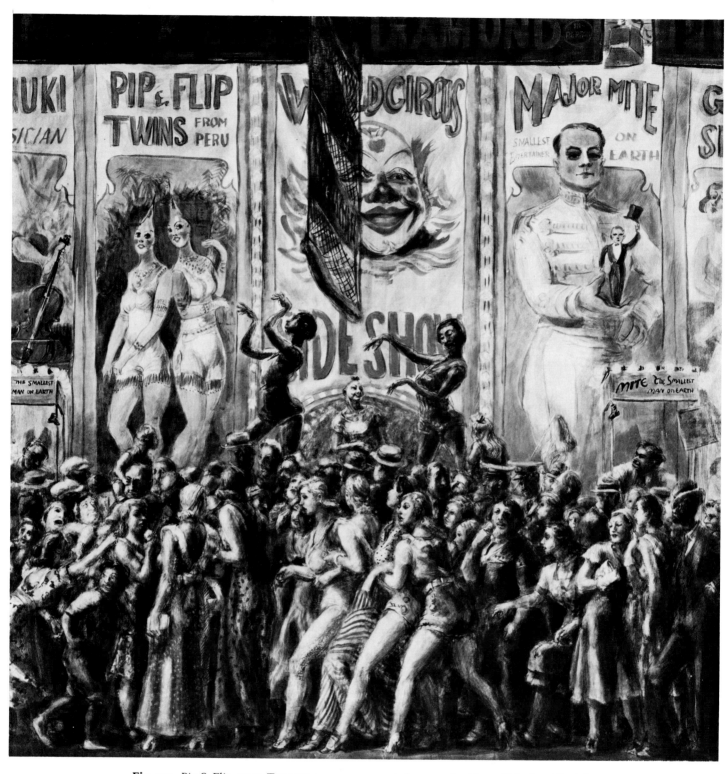

Fig. 130. *Pip & Flip*, 1932. Tempera on canvas mounted on panel, 48¼ × 48¼ inches. Daniel J. Terra Collection, Terra Museum of American Art, Evanston, Illinois. (In color on back cover)

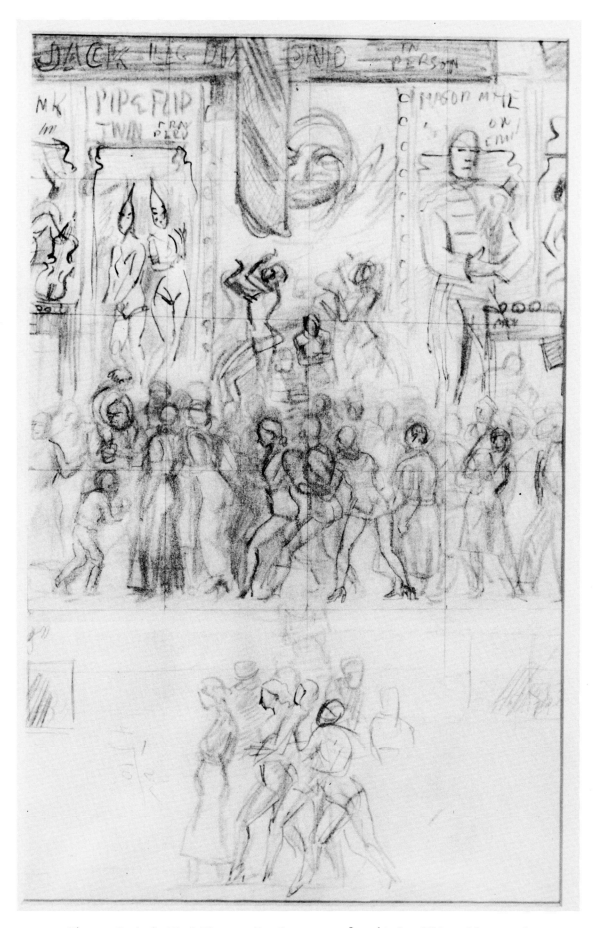

Fig. 131. Study for *Pip & Flip*, 1932. Pencil on paper, 14⅞ × 9½ inches. Whitney Museum of American Art, New York; Bequest of Felicia Meyer Marsh.

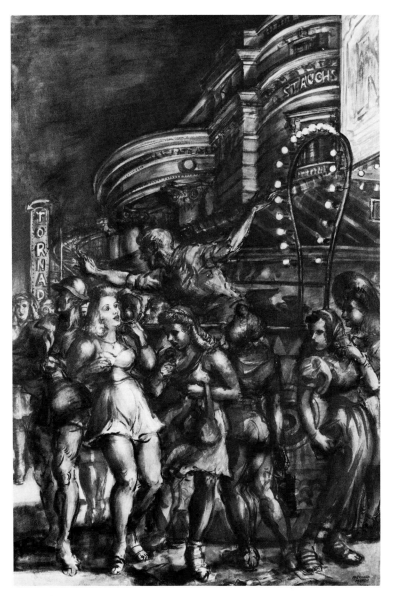

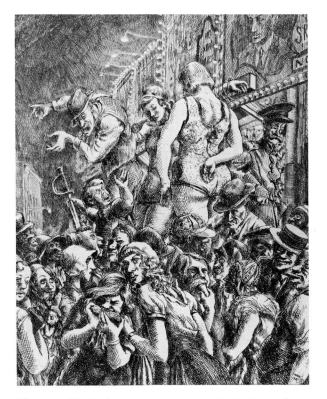

Fig. 132. *New Dodgem*, 1940. Watercolor on paper, $40\frac{1}{4} \times 26\frac{3}{4}$ inches. Whitney Museum of American Art, New York; Gift of the artist 53.21.

Fig. 133. *The Barker*, 1931 (restruck 1969). Etching, $9\frac{7}{8} \times 7\frac{3}{4}$ inches. Whitney Museum of American Art, New York; Original plate donated by William Benton 69.97f.

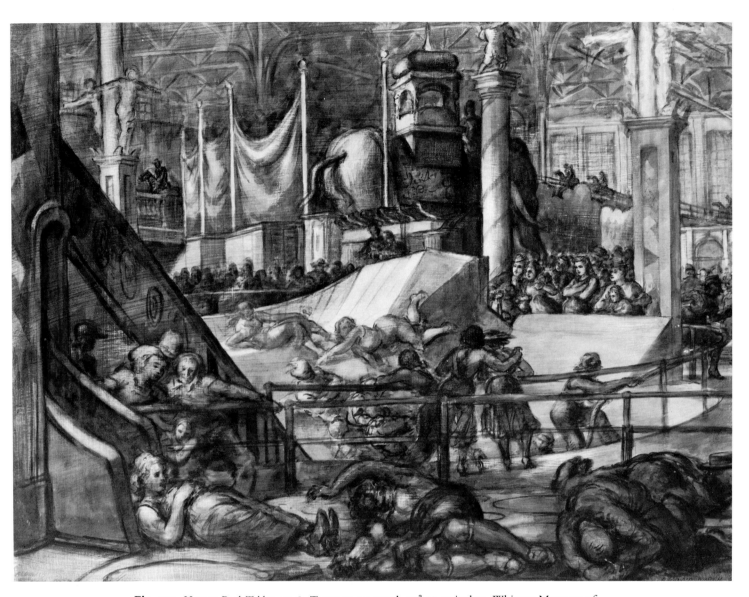

Fig. 134. *Human Pool Tables*, 1938. Tempera on panel, 29¾ × 40 inches. Whitney Museum of American Art, New York; Gift of Felicia Meyer Marsh and William Benton 55.34.

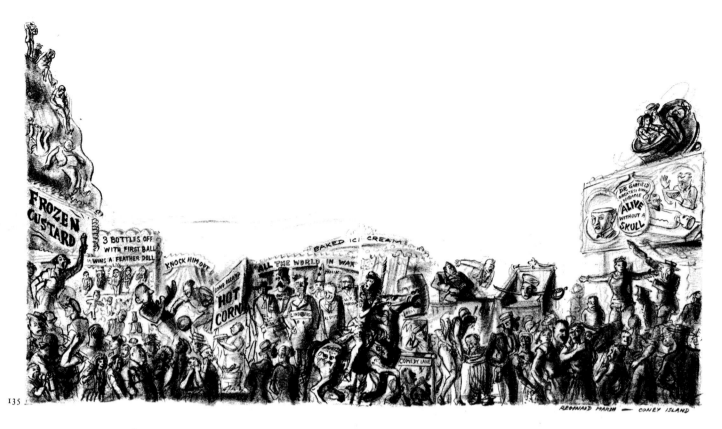

135

Fig. 135. "Coney Island," from *The New Yorker*, July 12, 1930. Clipping in scrapbook no. 5. Reginald Marsh Papers, Archives of American Art, Smithsonian Institution, Washington, D.C.

Fig. 136. Custard stand, 1931. Sketchbook no. 103. The Metropolitan Museum of Art, New York; Bequest of Felicia Meyer Marsh.

Fig. 137. Coney Island, 1939. Photograph. Print Archives, Museum of the City of New York; Bequest of Felicia Meyer Marsh.

Fig. 138. *Frozen Custard*, 1939. Etching, 7 × 10 inches. The William Benton Museum of Art, University of Connecticut, Storrs.

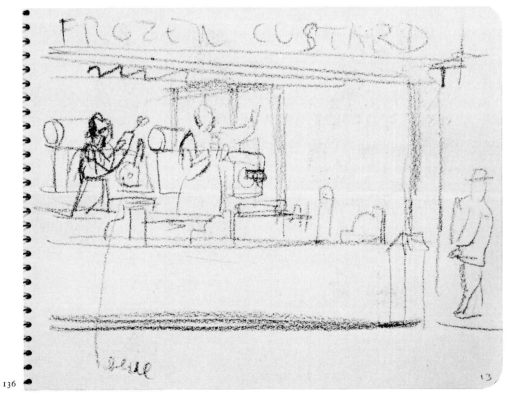

136

137

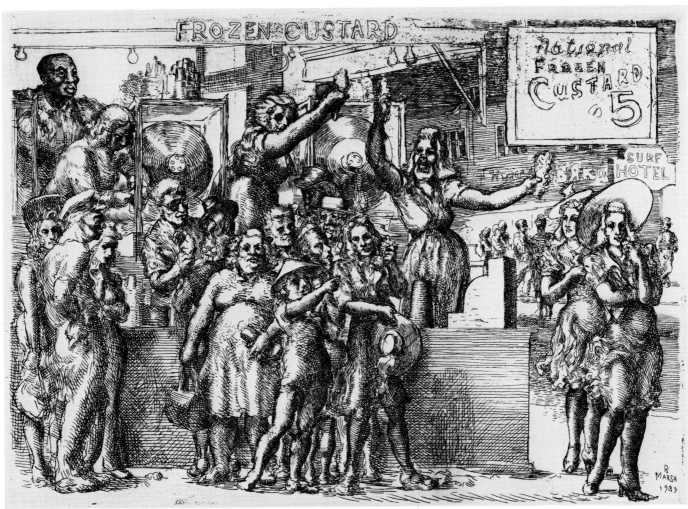

138

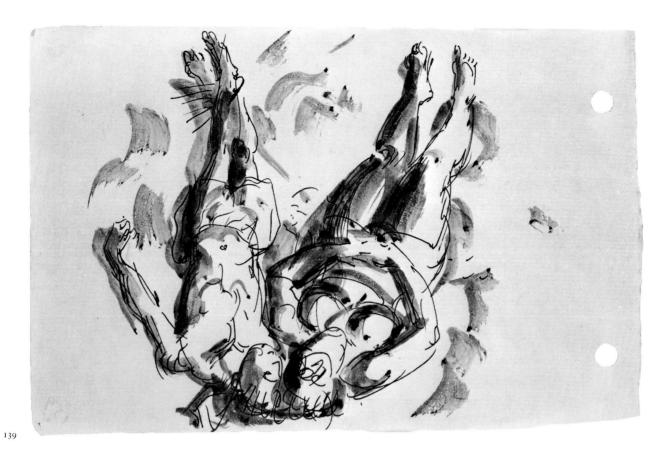

139

Fig. 139. Beach, 1947. Sketchbook no. 186. The Metropolitan Museum of Art, New York; Bequest of Felicia Meyer Marsh.
Fig. 140. Coney Island, 1938. Photograph. Print Archives, Museum of the City of New York; Bequest of Felicia Meyer Marsh.

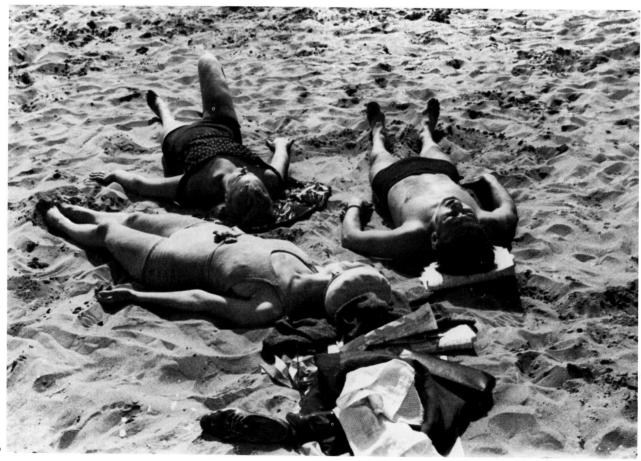

140

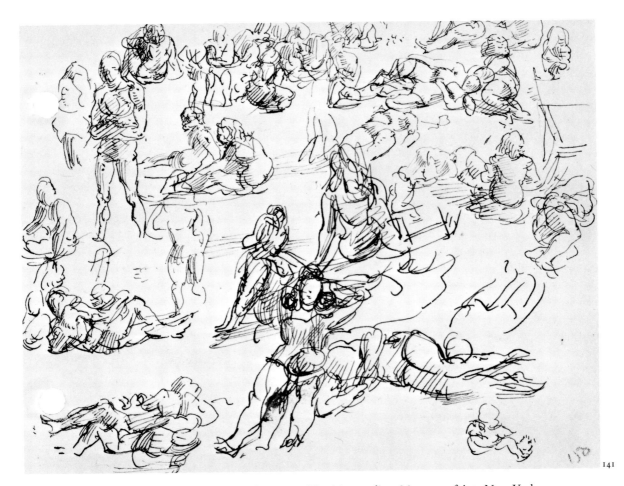

Fig. 141. Beach, 1939. Sketchbook no. 196. The Metropolitan Museum of Art, New York; Bequest of Felicia Meyer Marsh.
Fig. 142. Coney Island, 1938. Photograph. Print Archives, Museum of the City of New York; Bequest of Felicia Meyer Marsh.

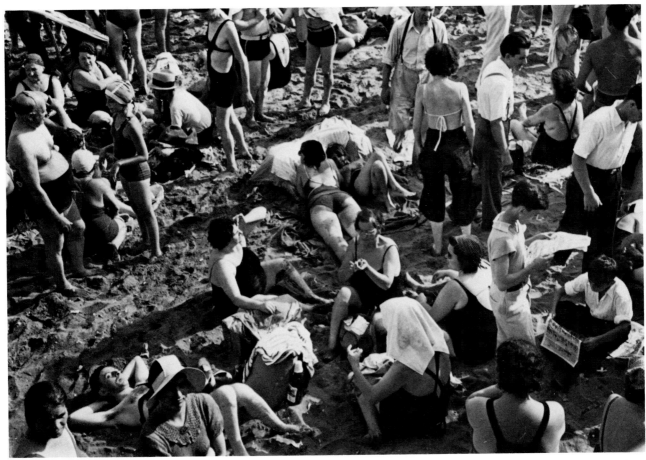

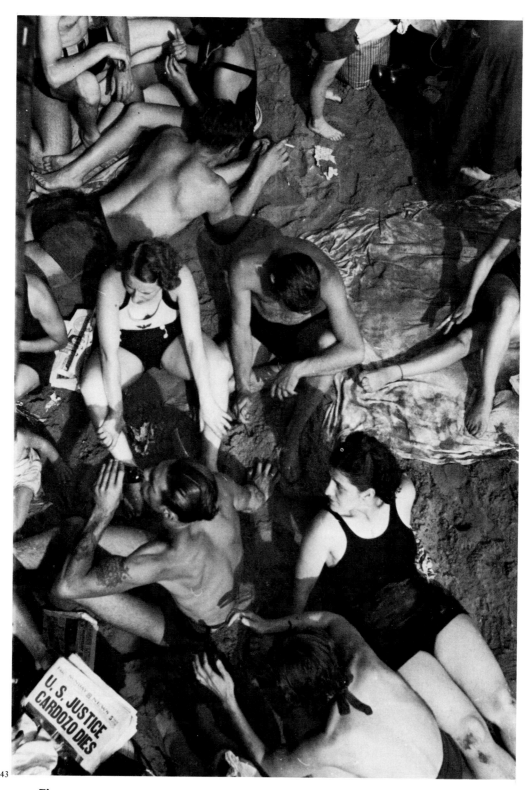

143

Figs. 143–145. Coney Island, 1938. Photographs. Print Archives, Museum of the City of New York; Bequest of Felicia Meyer Marsh.

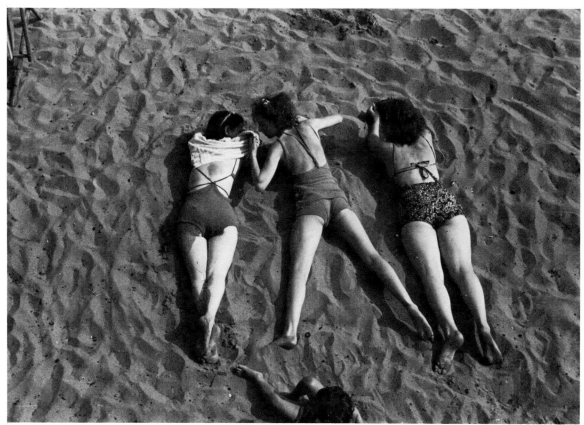

144

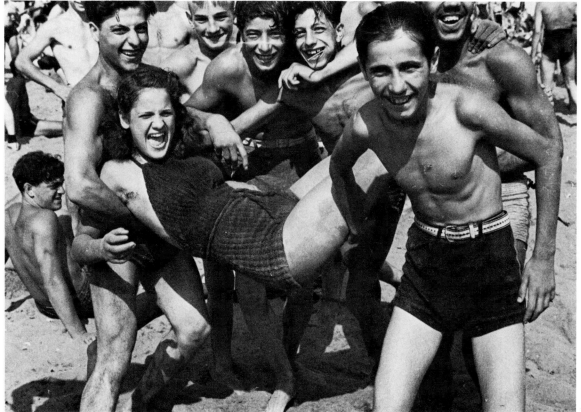

145

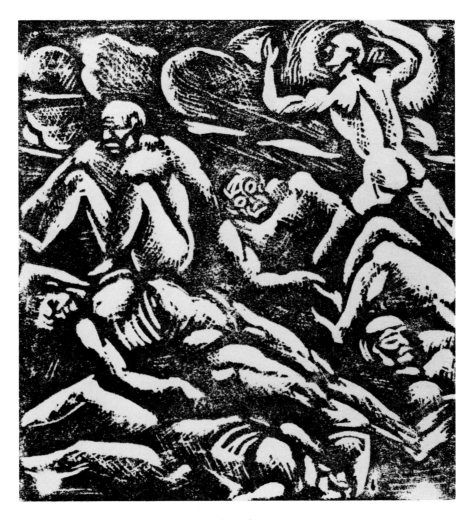

Fig. 146. *Resurrection*, c. 1921. Linocut, $5\frac{1}{8} \times 4\frac{3}{4}$ inches. Yale University Art Gallery, New Haven, Connecticut; Bequest of Mabel Van Alstyne Marsh.

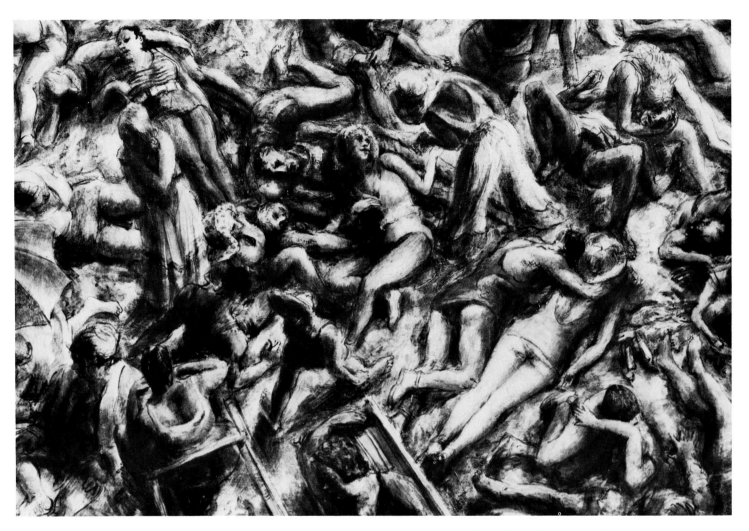

Fig. 147. *Hot Afternoon*, 1931. Tempera on panel, 16 × 24 inches. Collection of Marjorie and Charles Benton.

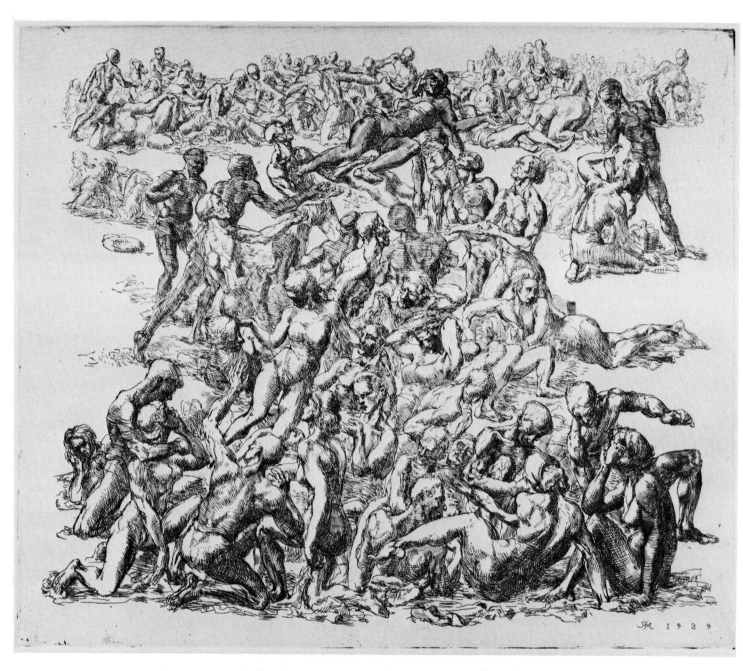

Fig. 148. *Coney Island Beach No. 1,* 1939 (restruck 1969). Etching, 9⅝ × 11⅝ inches. Whitney Museum of American Art, New York; Original plate donated by William Benton 69.97y.

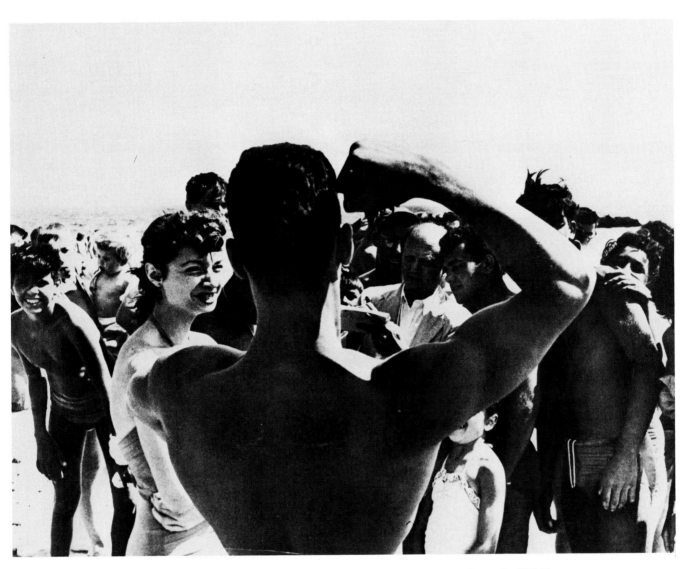

Fig. 149. Marsh sketching at Coney Island, c. 1950. Collection of Mr. and Mrs. Joel W. Harnett.

SELECTED
BIBLIOGRAPHY

Baigell, Matthew. *The American Scene: American Painting of the 1930's.* New York: Praeger Publishers, 1974.

Benton, William. "Reg Marsh—American Daumier." *Saturday Review*, December 24, 1955, pp. 8–9.

Blossom, Frederick A. "Reginald Marsh." *Creative Art*, 12 (April 1933), pp. 256–65.

Burroughs, Alan. "Young America—Reginald Marsh." *The Arts*, 3 (February 1923), pp. 138–39.

Garver, Thomas H. *Reginald Marsh: A Retrospective Exhibition* (exhibition catalogue). Newport Beach, Calif.: Newport Harbor Art Museum, 1972.

Goodrich, Lloyd. "Reginald Marsh: Painter of New York in Its Wildest Profusion." *American Artist*, 19 (September 1955), pp. 18–23, 61–63.

———. *Reginald Marsh.* New York: Harry N. Abrams, Inc., 1972.

———. "Lloyd Goodrich Reminisces: Part 1" (interview). *Archives of American Art Journal*, 20, no. 3 (1980), pp. 3–18.

Kramer, Hilton. "Marsh's Search for a Style." *New York Times*, June 24, 1979, section 2, p. 31.

Laning, Edward. "Reginald Marsh." *Demcourier*, 13 (June 1943), pp. 3–7, 16.

———. *The Sketchbooks of Reginald Marsh.* Greenwich, Conn.: New York Graphic Society Ltd., 1973.

Marsh, Reginald. "What I See in Laning's Art." *Creative Art*, 12 (March 1933), pp. 186–88.

———. "A Short Autobiography." *Art and Artists of Today*, 1 (March 1937), p. 8.

———. "Let's Get Back to Painting." *Magazine of Art*, 37 (December 1944), pp. 292–96.

———. Editorial in *The League* (The Art Students League of New York), July 1944, unpaginated.

———. "Kenneth Hayes Miller." *Magazine of Art*, 45 (April 1952), pp. 170–71.

Sasowsky, Norman. *The Prints of Reginald Marsh.* New York: Clarkson N. Potter, Inc., 1976.

———. "Reginald Marsh's Photographs." In *Photographs of New York by Reginald Marsh* (portfolio). Washington, D.C.: Middendorf Gallery and Jem Hom in conjunction with the estate of Reginald Marsh, 1977.

Sheesley, Drue Ann. *Reginald Marsh* (exhibition catalogue). Kalamazoo, Mich.: Kalamazoo Institute of Arts, 1973.

Young, Mahonri Sharp. "The Fourteenth Street School." *Apollo*, 113 (March 1981), pp. 170–71.

CATALOGUE

Dimensions are in inches, height preceding width, and refer to sheet size for drawings and plate size for prints. An asterisk indicates that a work will be shown only at the Whitney Museum of American Art at Philip Morris, two asterisks that a work will appear only in the traveling exhibition.

PAINTINGS

People Seated and Standing on Subway, c. 1928
Oil on canvas, 36 × 48
Whitney Museum of American Art, New York;
 Bequest of Felicia Meyer Marsh 80.31.8

Why Not Use the "L"?, 1930
Tempera on panel, 36 × 48
Whitney Museum of American Art, New York;
 Purchase 31.293

Chatham Square, 1931
Tempera on panel, 47½ × 35¼
Archer M. Huntington Art Gallery, University of
 Texas, Austin; The James and Mari Michener
 Collection

Holy Name Mission, 1931
Tempera on panel, 35½ × 47½
Collection of International Business Machines
 Corporation, Armonk, New York

Pip & Flip, 1932
Tempera on canvas mounted on panel, 48¼ × 48¼
Daniel J. Terra Collection, Terra Museum of
 American Art, Evanston, Illinois

Lifeguards, 1933
Tempera on panel, 35½ × 23⅝
Georgia Museum of Art, University of Georgia,
 Athens; Purchased from the United States
 Department of State, War Assets Administration

Star Burlesk, 1933
Tempera on panel, 48 × 36
The Regis Collection, Minneapolis, Minnesota

Ten Cents a Dance, 1933
Tempera on panel, 36 × 48
Whitney Museum of American Art, New York;
 Bequest of Felicia Meyer Marsh 80.31.10

Coney Island Beach, 1934
Tempera on panel, 36 × 40
Yale University Art Gallery, New Haven,
 Connecticut; Gift of Felicia Meyer Marsh

Negroes on Rockaway Beach, 1934
Tempera on panel, 30 × 40
Whitney Museum of American Art, New York;
 Gift of Mr. and Mrs. Albert Hackett 61.2

*******Paramount Pictures*, 1934
Tempera on panel, 36 × 30
Collection of Marjorie and Charles Benton

Minsky's Chorus, 1935
Tempera on panel, 30 × 36
Whitney Museum of American Art, New York;
 Promised gift of Mr. and Mrs. Albert Hackett in
 honor of Edith and Lloyd Goodrich

A Morning in May, 1936
Tempera on panel, 24 × 30
Private collection

* *Twenty Cent Movie*, 1936
Tempera on panel, 30 × 40
Whitney Museum of American Art, New York;
 Purchase 37.43

** *Coney Island Beach*, 1939
Tempera on panel, 29½ × 49½
Collection of Marjorie and Charles Benton

DRAWINGS

Olympic Theatre, 14th Street, c. 1923
Ink on paper, 22 × 6½
Collection of Marjorie and Charles Benton

** *A Model for 10¢*, c. 1927–30
Ink on paper, 9 × 11½
Whitney Museum of American Art, New York;
 Bequest of Felicia Meyer Marsh 80.31.102

Sketch after Rubens' *Diana Surprised by Satyrs*,
 c. 1928
Chinese ink and pencil on paper, 11 × 8½
Whitney Museum of American Art, New York;
 Bequest of Felicia Meyer Marsh 80.31.111

** Burlesque audience, c. 1929 (from sketchbook
 no. 132)
Ink on paper, 6⅞ × 4¾
The Metropolitan Museum of Art, New York;
 Bequest of Felicia Meyer Marsh

** Burlesque theater, c. 1929 (from sketchbook no. 132)
Ink on paper, 6⅞ × 4¾
The Metropolitan Museum of Art, New York;
 Bequest of Felicia Meyer Marsh

People on a subway, c. 1930
Charcoal pencil on paper, 4½ × 7 1/16
Whitney Museum of American Art, New York;
 Bequest of Felicia Meyer Marsh T78.1.753

I.R.T., 1932
Charcoal pencil on paper, 10 × 8
Whitney Museum of American Art, New York;
 Bequest of Felicia Meyer Marsh T78.1.1021

Sketch for *Bread Line—No One Has Starved*, 1932
Pencil on paper, 8½ × 14
Whitney Museum of American Art, New York;
 Bequest of Felicia Meyer Marsh 80.31.29

Study for *Pip & Flip*, 1932
Pencil on paper, 14⅞ × 9½
Whitney Museum of American Art, New York;
 Bequest of Felicia Meyer Marsh

Studies for *Lifeguards*, 1933
Pencil on paper, 15 × 10½
Whitney Museum of American Art, New York;
 Bequest of Felicia Meyer Marsh T78.1.1103

Study for *Coney Island Beach*, 1934
Ink on tracing paper, 10⅝ × 10
The William Benton Museum of Art, University of
 Connecticut, Storrs

*Four sketches for *Twenty Cent Movie*, 1936 (from
 sketchbook no. 169)
Ink on paper, 4½ × 6 each
The Metropolitan Museum of Art, New York;
 Bequest of Felicia Meyer Marsh

*Study for *Twenty Cent Movie*, 1936
Ink and pencil on paper, 9½ × 12⅜
Whitney Museum of American Art, New York; Gift
 of Edith and Lloyd Goodrich 73.1

PRINTS

Audience Burlesk, 1929
Etching, 6 × 8
The William Benton Museum of Art, University of
 Connecticut, Storrs

Gaiety Burlesque, 1930
Etching, 11 13/16 × 9¾
Whitney Museum of American Art, New York;
 Purchase 31.777

Bread Line—No One Has Starved, 1932
Etching and engraving, 6⅜ × 11⅞
Whitney Museum of American Art, New York;
 Katherine Schmidt Shubert Bequest 82.43.1

Tattoo—Shave—Haircut, 1932
Etching, 10 × 10
The William Benton Museum of Art, University of
 Connecticut, Storrs

Coney Island Beach, 1934
Etching, 9¾ × 9¾
Whitney Museum of American Art, New York;
 Katherine Schmidt Shubert Bequest T80.2.22

Smokehounds, 1934
Etching, 12 × 9
The William Benton Museum of Art, University of
 Connecticut, Storrs

Striptease at New Gotham, 1935
Etching, 12 × 9
The William Benton Museum of Art, University of
 Connecticut, Storrs

** *Coney Island Beach No. 1*, 1939 (restruck 1969)
Etching, 9⅝ × 11⅝
Whitney Museum of American Art, New York;
 Original plate donated by William
 Benton 69.97y

Diana Dancing Academy, 1939
Engraving, 8 × 10
The William Benton Museum of Art, University of
 Connecticut, Storrs

Pickaback, 1939 (restruck 1969)
Engraving, 9⅞ × 4⅞
Whitney Museum of American Art, New York;
 Original plate donated by William
 Benton 69.97v

SKETCHBOOKS

Sketchbook (no. 126), c. 1924–35
Whitney Museum of American Art, New York;
 Bequest of Felicia Meyer Marsh T78.1.858

Sketchbooks (nos. 47, 59, 61, 83, 102, 103, 109, 130,
 160, 179), 1930–38
The Metropolitan Museum of Art, New York;
 Bequest of Felicia Meyer Marsh

PHOTOGRAPHS

A representative selection of photographs (c. 1938–40)
of the Bowery, Coney Island, theaters, and the sub-
way, and four snapshots (c. 1933) of beaches, from the
Print Archives, Museum of the City of New York:
Bequest of Felicia Meyer Marsh. The copy prints in
the exhibition approximate the sizes of Marsh's origi-
nal prints (photographs 5 × 7 inches, snapshots $3\frac{1}{2}$ ×
$4\frac{1}{2}$ inches); however, Marsh did not intend his photo-
graphs to be works of art and his own developing and
printing were not carefully done.

Photograph of Marsh sketching at Coney Island,
c. 1950. Collection of Mr. and Mrs. Joel W. Harnett.

DOCUMENTS

A representative selection of materials from the
Reginald Marsh Papers, Archives of American Art,
Smithsonian Institution, Washington, D.C., includ-
ing notebooks, scrapbooks, calendars, diaries, and
letters.

PHOTOGRAPH CREDITS

Photographs have been provided, in most cases, by the owners or custodians of
the works, as cited in the captions. The following list applies to photographs for
which an additional acknowledgment is due.

Oliver Baker: Fig. 57
E. Irving Blomstrann: Figs. 51, 84
Geoffrey Clements: front cover; Figs. 1, 9, 15, 20, 21, 26,
 32, 34, 35, 37, 42, 45, 47–50, 52, 61–63, 65, 66, 69, 80,
 81–83, 92, 98, 103, 108–110, 112, 113, 115, 116, 122, 125,
 127, 131–133, 138, 146, 148
Marilyn Cohen: Figs. 12, 16, 17, 25, 139, 141
eeva-inkeri: Fig. 55

Roy M. Elkind: Figs. 30, 36, 104
Peter A. Juley & Son: Fig. 134
Tom Kochel: frontispiece; Figs. 2–6, 10, 11, 22, 24, 53, 54,
 85, 135
James Maroney: Fig 126.
William George Murray: back cover
Charles Uht: Fig. 79